IMAGES
of America

PHOENIX ZOO

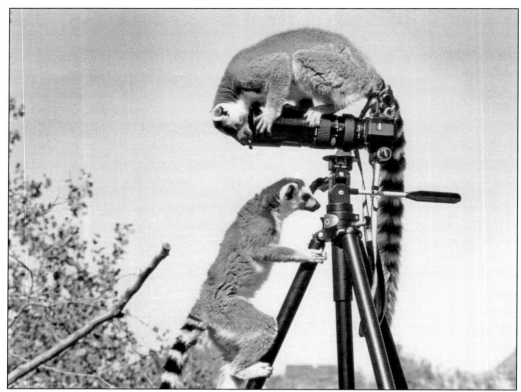

These ring-tailed lemurs at the Phoenix Zoo have turned the tables on photographers by commandeering their camera. In 1874, some zoos started displaying animals differently. The focus of the animal's habitat was how they would be in their native wild. Not only are the animals free to roam, but the absence of bars makes for great photo ops. (Courtesy of the Phoenix Zoo.)

ON THE COVER: Ruby the Asian elephant was the painting pachyderm of the Phoenix Zoo. Considered the main attraction at the zoo, Ruby would pick up a paintbrush and create abstract works of art directly on a canvas. Once called the "largest" figure in Southwestern art, she developed a fan base. Zookeepers Tawny Carlson (left) and Anita Schanberger (right) act as postal carriers delivering Ruby's fan mail. (Courtesy of the Phoenix Zoo.)

IMAGES
of America

PHOENIX ZOO

Debbie Veldhuis

ARCADIA
PUBLISHING

Published by Arcadia Publishing
Charleston, South Carolina

Printed in the United States of America

Library of Congress Control Number: 2017956446

For all general information, please contact Arcadia Publishing:
Telephone 843-853-2070
Fax 843-853-0044
E-mail sales@arcadiapublishing.com
For customer service and orders:
Toll-Free 1-888-313-2665

Visit us on the Internet at www.arcadiapublishing.com

This is dedicated to my partner in childhood adventures: my brother Doug Veldhuis. When we were growing up in the 1960s, Phoenix was a young town, and it was a special day when the new Phoenix Zoo opened. It was our first zoo, and we have watched it grow. From the fiberglass bunnies at the children's zoo to the arrival of Baltimore Jack . . . it is our zoo.

CONTENTS

ACKNOWLEDGMENTS

I wish to express my sincerest appreciation to the staff at the Phoenix Zoo. Whether I was walking around the zoo or diving into all its archived materials, everyone was wonderfully friendly and helpful. A special thank-you goes to Linda Hardwick, the director of communications for the Phoenix Zoo–Arizona Center for Nature Conservation. She was my starting point with the zoo and helped pave the way for my access to the archived materials. She also answered many of my questions or found a source for me to look through or speak with.

Part of my journey through the various files was a trip down memory lane. But most of the time, I too was learning something new. A thank-you is offered to those who came before who had the foresight to save every scrap of paper, flyer, and even grocery bag to archive for future explorers to find.

Unless otherwise noted, all images appear courtesy of the Phoenix Zoo.

INTRODUCTION

The first North American zoo was established in Philadelphia in 1874. The zoo opened with three central goals: public recreation, wildlife preservation, and scientific conservation.

In the late 1950s, Phoenix's population and commercial growth were outpacing its cultural development. This concerned many, since Phoenix was already the second-largest city in the Rocky Mountain region. Phoenix would soon overtake Denver as the largest city in its region. But it lacked many of the cultural resources of a genuine big city, most notably a first-class zoo.

In a March 2005 *Baltimore Sun* article, G. Jefferson Price III writes, "No city in the union can call itself genuine without a zoo of its own." But a zoo doesn't just spring up overnight. It takes a group of dedicated men and women who have the same dream or goal and are socially and financially able to keep their eyes on the prize: in this case, a shiny new zoo in what was then in the heart of Phoenix.

It would take a decade, but Phoenix would get its zoo thanks to a bunch of dedicated amateurs led by the grandson of the founder of perhaps America's most famous maker of washing machines.

Robert E. Maytag, the grandson of F.L. Maytag Sr., founder of the Maytag Company of Newton, Iowa, was an energetic 38-year-old with active interests in wildlife and conservation. He spent three years in East Africa in the 1950s studying birds and supervising a team to assemble the world's largest scientific collection of fish from that region. During this time, he was also director of the International Oceanographic Foundation. Maytag was independently wealthy and looking for something purposeful to do with his life. His wife, Nancy, suggested they build a zoo in Phoenix.

Maytag knew he could not do it alone, so one evening, they hosted a party, inviting their closest friends for a casual evening of cocktails and conversation. When the topic of building a zoo came up, Maytag discovered that individually they had been thinking along the same lines.

The next time they met, their numbers had grown to 15. The group would be incorporated as the Arizona Zoological Society and be formally established as a nonprofit organization. Maytag called their group "a bunch of dedicated amateurs," and the challenge of building a zoo in Phoenix began.

Three broad challenges faced the Arizona Zoological Society: First, it had to succeed where others had failed in fundraising (a group prior to this, the Children's Zoo Committee, was unable to raise sufficient funds). Next came finding a suitable site for the zoo and researching and formulating a plan for the grounds. Then finally, "What to call it?"

From the first, the Arizona Zoological Society had some advantage over the earlier zoo groups—it had Robert Maytag. His name carried enormous influence, and he shrewdly used it as well as his personal wealth towards the campaign to build the zoo.

He started things off with a donation of $100,000. Next, he began to call on the valley's most prominent citizens to enlist their aid. But he did not stop with corporation presidents; Maytag could talk as readily to a janitor about the new zoo. To Maytag, it made little difference if he got a cash donation, goods, or labor, as long as he got something, and he usually did. But Maytag made it clear from the start that he was not going to buy the zoo outright. He would give his share, but the zoo project would succeed or fail according to the support it got from the community.

The board also determined that the new zoo would be privately owned and operated, similarly to the San Diego Zoological Society. The Arizona Zoological Society would go one step further and would also be completely self-supporting and would accept no tax monies whatsoever. There

were two reasons for this decision: one, the founders did not want the zoo to be an additional tax burden on the community; and two, they wanted it to, if possible, operate independently of any governmental agencies.

So, the question to Phoenix citizens was, "Do you want a zoo in Phoenix?"

The idea of a zoo did not meet with immediate acceptance. From the start, there were naysayers who said it could not be done, as well as indifference and outright opposition. Some residents responded with "Why bother?" They had gotten by this long without a zoo, so why did they need one now? Others were concerned for the animals, saying that zoos were nothing more than prisons.

The society aroused the public interest though lectures, speeches, letter writing campaigns, and personal conversation. It convinced companies and corporations of the earnestness and importance of its plans.

Financial and physical support came in when public leaders fell in line behind the society. Soon, public service and civic organizations and other groups started volunteering, saying, "Give us bigger things to do; let us help build the zoo."

Prominent Arizonians, in both business and finance, donated funds for buildings and entire exhibits. First graders pooled their pennies. Candy sales, fashion shows, and theater parties became the water for growing the seeds planted by the society. The spirit of Arizona citizens watered these seeds.

It even went beyond the state's borders as residents of other states called on the society to ask what they might give.

The result of all this would be for each and every individual to take pride in not just the "Phoenix Zoo" but "my zoo," "our zoo," or "your zoo!"

Every imaginable means to earn support for the zoo was tried. A membership drive was initiated. Before construction on the zoo had even begun, over 1,000 memberships were sold in 1961.

Even the animals arrived before the zoo was built. Every animal the society acquired found temporary quarters, usually at the Maytag residence and usually covered by reporters and photographers from all over the metropolitan area.

Meanwhile, no gathering of people was safe from zoo fundraisers. They showed up everywhere and most often with one or two recently acquired animals. By the end of 1961, Heffalump, the infant Asian elephant, and Beau Brummell, the woolly monkey, were widely known throughout the city.

And it was working. By November, the society had gathered $384,000, including Robert Maytag's original $100,000 donation.

The second major hurdle facing Arizona Zoological Society was finding a suitable location for the zoo and planning its construction. The site selection committee came up with six possibilities, but the best of the six was Papago Park. The park was several miles east of downtown Phoenix but centrally located and easily accessible from Phoenix, Scottsdale, Tempe, Mesa, and Arizona State University (ASU).

The site could be readily developed into an attractive zoo because it already had trees, lakes, rocky buttes, and a varied terrain that offered unlimited potential. The best part of land was the southwest corner of the park. It would be ideal for the new zoo. There was only one problem: the site was already occupied.

Friendly but complicated negotiations between the Arizona Zoological Society, the Arizona Game and Fish Department, and the City of Phoenix took place until a mutually satisfactory settlement was reached. It took six months to work out the legal dialogue of the agreement. Game and Fish would vacate the Papago Park, and the Arizona Zoological Society could lease the land from the city for a dollar. The partially undeveloped tract would later be described as the most scenic zoo setting in the United States.

So what to build? With the help of other zoo professionals as advisors, a basic plan began to evolve. The Phoenix Zoo would be the first new zoological park built in the US in 25 years. It would be innovative in its circular arrangement with pie-shaped wedges. Each wedge represented one of the continents.

An October 1961 news release informed the inquiring public of some of the details. Namely, the zoo would be opened in November 1962 with an initial funding of $2.1 million. This amount would be increased by an additional $1 million annually. By 1965, the society planned the zoo to have a total investment of over $5 million. The society envisioned that the Phoenix Zoo by then would have attained the size and quality of the San Diego Zoo.

The search for a zoo director was more successful. After a nationwide search, the society selected a candidate with whom it was already well-acquainted: Robert Matlin of Crandon Park. Matlin had served at zoos in Cleveland and Salt Lake City before becoming the director in Miami in 1955. He was the past president of the American Association of Zoological Parks and Aquariums. Matlin was widely regarded as one of the most promising zoo professionals in the country. He was personable and proved to be an effective representative of the project.

The next thing to overcome was "What to name the zoo?" A name had not yet been settled on. Arizona Zoological Park, Arizona Zoo, Arizoo, Papago Park Zoo, and the Maytag Zoo were all nominated as possible candidates. Robert Maytag was opposed to naming the zoo after him or the Maytag family. He argued this would not generate the public's support. People would withhold their own contributions. Maytag Zoo? Then Maytag money can pay for it all. Nevertheless, most members of the community were distinctly pleased to give some measure of support to the zoo. Proof came in November when, in recognition for his efforts to better the community, the Phoenix Realty Board chose Robert Maytag as its "Man of the Year" for 1961.

The official zoo ground breaking took place on January 20, 1962. To the delight of onlookers and in true zoo fashion, Lorenzo the donkey and Heffalump the elephant was hitched to a plow and broke ground signaling the start of one man's dream, a zoo in Phoenix.

After the ground breaking, the frenzy of fundraising and planning continued. Through the summer of 1962, a day did not go by without some media story about the zoo. Fundraising events were sponsored by social and fraternal organizations. Companies advertised their support.

Things really were beginning to happen. The executive vice president of the society, C. Tim Rodgers, a contractor and developer by profession, oversaw all of the construction. He had left his own business six months earlier to work with Maytag as a full-time employee of the Arizona Zoological Society. Like the other society members, Rogers had a long stint on the zoo's publicity circuit, attending meetings and making speeches, but he was glad to finally go to work on actually building the zoo.

The first area undertaken was the construction of the Children's Zoo. Architect E. Logan Campbell created a playful design that Rogers and his crew gradually built into a combination barnyard and fantasyland for younger zoo visitors.

Then tragedy struck in March. Maytag was going to spend a weekend aboard his yacht in San Diego before attending the society's annual meeting. He had developed a cold working out in the cold and damp at the zoo site prior to this. His condition worsened as his cold developed into pneumonia. The fact he was allergic to penicillin complicated the treatment. On the early morning of March 14, 1962, Robert Maytag died at the age of 38. The zoo was no longer his dream: it would be his memorial.

On March 18, the annual meeting was held as scheduled. At this time, Nancy Maytag was elected as the second president of the Arizona Zoological Society, assuming her husband's role.

Maytag had been the face of the zoo, and with his death, there was some question if the project would move forward. Would people still pledge? Enter media mogul Eugene Pulliam, who pledged $130,000 for the construction of the Arizona Exhibit. This show of support helped keep the zoo effort going.

One

DO YOU WANT
A ZOO IN '62?

To keep the momentum going, the society needed to keep the zoo in the hearts and minds of Arizona. "We racked our brains to get support for the zoo," remembers Nancy Maytag Love. "Some of the things we did were pretty corny in retrospect, but most of them worked out well and that's what was important."

Every animal the society acquired found its arrival in temporary quarters, usually the Maytag residence, and every arrival was covered by reporters and photographers from all over the metropolitan area. One radio station, KYND of Tempe, even began a weekly zoo program on Saturday mornings featuring Robert Maytag, C. Tim Rodgers, or another board spokesman discussing the progress of the zoo.

Community support for the zoo was the most gratifying thing of all. From the steady flow of donations of money, goods, services, and labor, there was only one conclusion to be made: Robert Maytag had been correct. The people of Arizona wanted a world-class zoo.

Maytag had made it clear from the start that he would not buy the zoo outright. He would give his share, but the zoo project would succeed or fail according to the support it received.

But did Phoenix still want a zoo? For a zoo to work, its benefactors, the public, would have to help. The help could be in the form of money, goods, or labor.

Through the summer of 1962, hardly a day went by without some news or feature story about the zoo. Work progressed satisfactorily, and zoo supporters felt their dream was in the process of coming true.

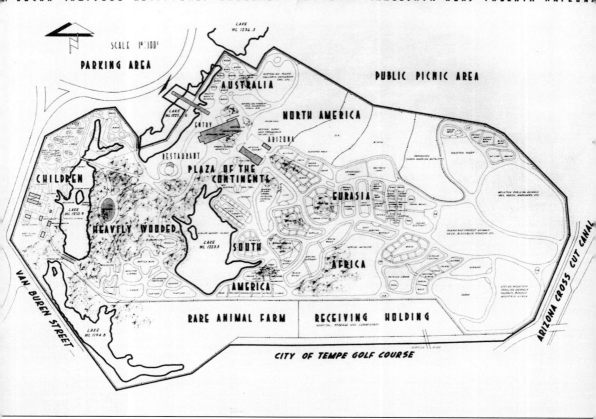

Pictured here are the architect's plans for the zoo's layout. With the help of other zoo professionals as advisors, a basic plan began to evolve on what to build on the site. It would be innovative in its circular arrangement with pie-shaped wedges. Each wedge would represent one of the continents.

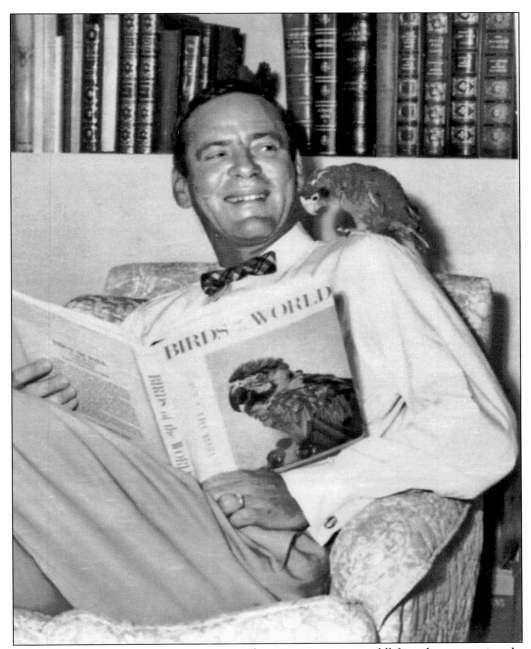

Robert E. Maytag was an energetic man with active interests in wildlife and conservation. In the 1950s, he spent three years in East Africa studying birds, and he was also director of the International Oceanographic Foundation. An independently wealthy man, Maytag was looking for something purposeful to do with his life. It was the idea of his wife, Nancy, to build a zoo in Phoenix. The community also showed its support for the idea of building a zoo by giving him recognition for his efforts. In 1961, the Phoenix Realty Board chose Robert Maytag as its Man of the Year.

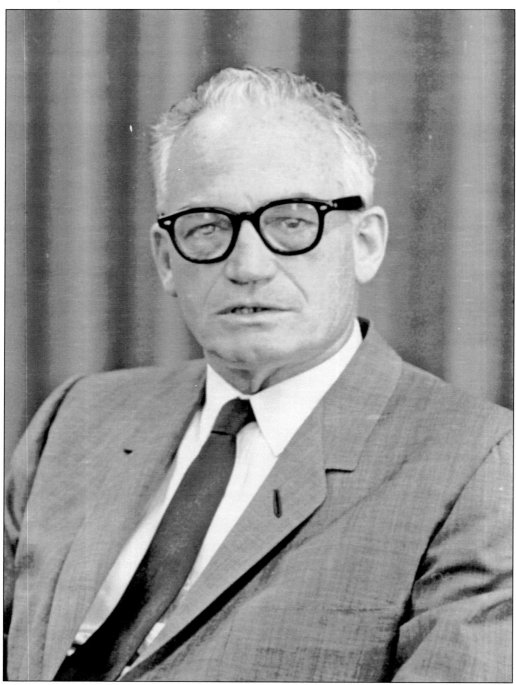

Barry Goldwater, US senator from Arizona, favored the idea of a zoo for Phoenix. "The Arizona Zoological Society had been formed and hard at work to provide a zoo. . . . To provide the youngsters of today with complete educational facilities should be the goal of all Arizona parents and because of this, I have no hesitancy in urging full support to the Zoological Society." (Prints & Photographs Division, Library of Congress.)

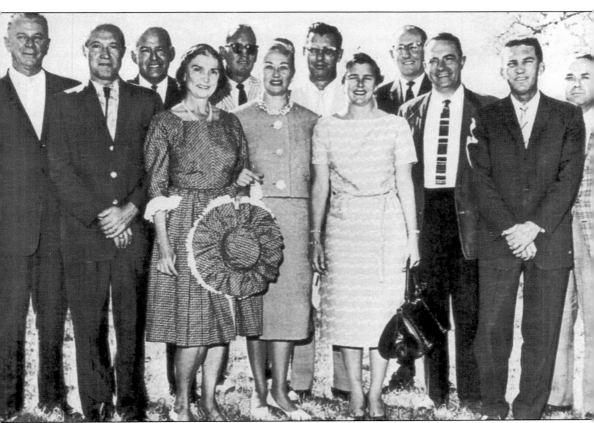

Maytag called the group "a bunch of dedicated amateurs." This group would be incorporated as the Arizona Zoological Society (AZS) and formally be established as a nonprofit organization. The first board of directors includes, from left to right, Robert L. Davenport, Theodore A. Rehm, Scott L. Libby, Virginia (Mrs. George) Ullman, James Allen, Ann Lee (Mrs. Jack A.) Harris, Arthur E. Dammann, Nancy (Mrs. Robert E.) Maytag, William G. Orr, Jacob M. Sobol, C. Tim Rodgers, and Jim Sexton.

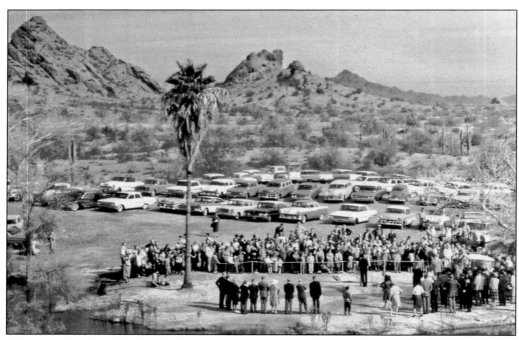

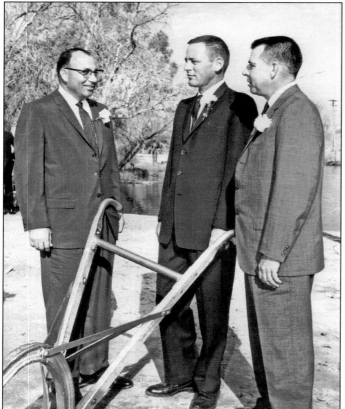

Surround by his board and a crowd of zoo supporters, Robert Maytag begins the lakeside ground-breaking ceremony for the zoo on January 20, 1962. As American cultural anthropologist Margaret Mead said, one should never underestimate what a small group of dedicated people can accomplish.

On ground-breaking day, (from left to right) Phoenix mayor Sam Mardian, Robert Maytag, and zoo director Robert Mattlin stand by the plow used to ceremoniously break through the sun-hardened Arizona soil. This tough caliche soil would prove to be an obstacle during the laying of the utilities.

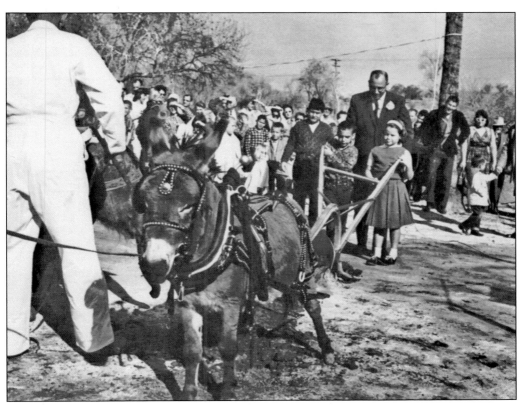

On January 20, 1962, then Phoenix mayor Sam Mardian, his son Douglas, and Estelle Burns (daughter of F. Britton Burns, an Arizona Zoological Society board member) break ground in true zoo fashion with a plow pulled by Lorenzo the donkey and an elephant named Heffalump (out of sight behind the donkey).

Robert Maytag stands at the podium on groundbreaking day. The Phoenix Zoo was his dream. He set the groundwork, and though many considered it the Maytag Zoo, he was quite insistent that it was the people of Phoenix's zoo.

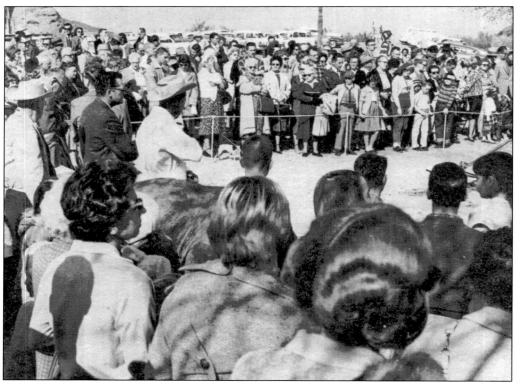

The ground-breaking ceremony brought out over 2,000 spectators. Were they really interested that Phoenix was getting a zoo or did they just want to see an elephant? Judging by the citizen response and donations, it was probably a little bit of both. Whatever reason brought them out, they even rode in on horseback.

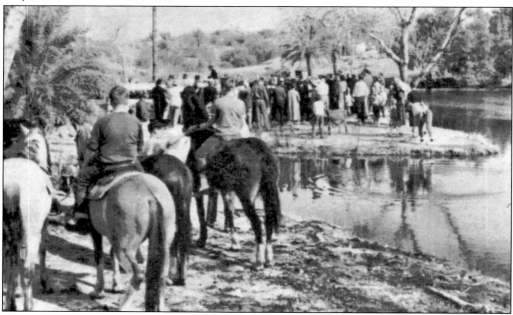

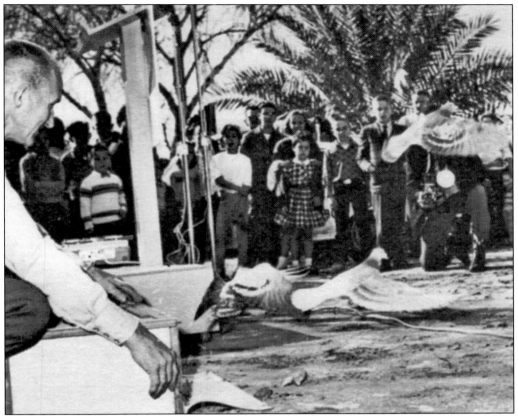

At the ground-breaking ceremony, Joseph Stoebr, of the Valley of the Sun Homing Pigeon Club, Inc., released three racing pigeons to return to their coop in west Phoenix.

An example of the slogan to rally the community behind building a zoo in Phoenix, this logo appeared on grocery bags and the sides of delivery trucks. Businesses could buy space in the local newspaper using this logo. Any tactic the society could think of was used to remind the public that their support was needed for the new zoo.

**From the
President's Desk**

February 1, 1962

Dear Members,

The Ground Breaking Ceremony was a great suc-
cess. We who have worked hard to bring the zoo
project into reality were very heartened by the
large crowd of people who attended the ceremony.
We feel it to be yet another illustration that the
citizens of Arizona want and need a zoo, and are
willing to work toward its establishment. We feel
it to be another 'vote of confidence' for the
worthiness of the project.

On behalf of the Board of Directors of the
Arizona Zoological Society, I wish to thank all of
those who participated in the program. We are also
greatly indebted to all those fine persons who
donated time and services in order that the pro-
gram might run smoothly.

Thank you very much.

Cordially,

Robert E. Maytag

Robert E. Maytag
President

This letter appeared in the membership news magazine *Arizoo* after the ground-breaking. It is a thank-you from Robert Maytag and also a reminder to keep up the good work.

This cartoon showed up in one of the local papers. It is open to interpretation if it is for or against opening a zoo in the desert.

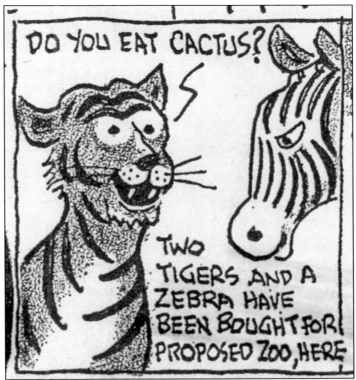

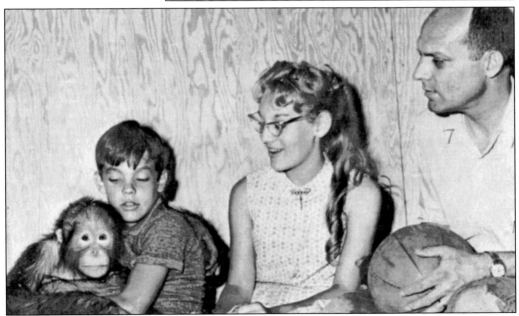

Duchess the orangutan is held by Mark Bimson while Pamela and Walter Bimson watch. In the early days of the zoo, it was not unusual for one of the Arizona Zoological Society board members to house an animal. There was no zoo yet, but there were animals arriving. Sometimes, the donation was from a disillusioned exotic pet owner.

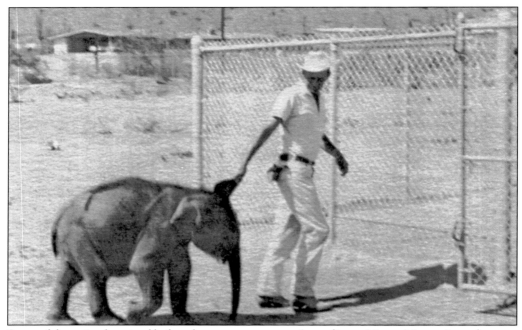

Some of the animals arrived before there even was a zoo. According to Nancy Maytag Love, because there was no zoo yet, most of the animals took up temporary residency at the Maytag's Scottsdale home on the east end of Camelback Mountain. "We had all kinds of birds, a brown bear, a zebra, donkeys, a baby elephant, gibbons, a woolly monkey, Bengal tiger cubs, and two baby gorillas." C.H. "Speedy" Barker (curator of animals) leads Heffalump by her ear to her enclosure.

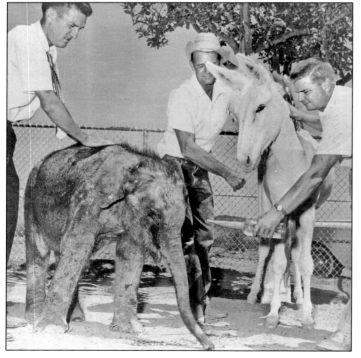

Maytag's own neighbors criticized the project. They wanted the return of a peaceful, non-jungle neighborhood. Their once quiet neighborhood was now being blasted by braying donkeys, shrieking parrots, unpredictable tiger roars, and an owl that hooted all night long. Then there were the outside lights that blazed at all hours as someone got up to feed the baby elephant. The Maytags pointed out that the quicker the zoo was built, the sooner the animals would leave. Some nice contributions came in this way, even though the donors' motives had nothing to do with the love of animals.

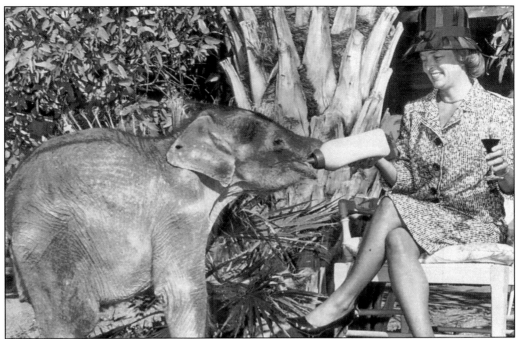

Meanwhile, no gathering of people was safe from zoo fundraisers. Zoo committee members showed up everywhere and most often with one or two recently acquired animals. By the end of 1961, Heffalump, the infant Asian elephant, and Beau Brummell, the woolly monkey, were widely known throughout the city.

Board members also held small private dinner parties at which one of the animals was the surprise guest. It was hard to resist a tiny elephant or to ignore a monkey. Unsuspecting guests opened their hearts and their checkbooks to such unorthodox measures (often referred to as "gorilla" warfare).

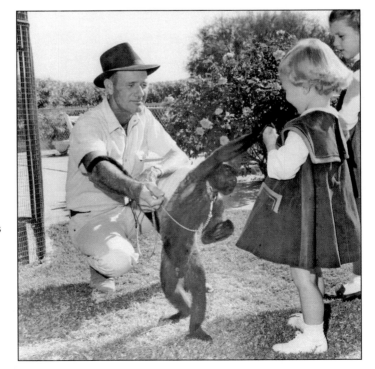

A zoo magazine, given the name *Arizoo* by society vice president Virginia Ullman, rolled off the presses and was mailed to members as well as prospective members. For the magazine's first year, there was not a real zoo to write about. But editor Babette DeBarr still produced lively monthly issues from nothing. Other zoos provided many of the animal photographs for *Arizoo*'s pages. This tiger graces the cover of the first edition.

To keep the zoo in the news and keep the public's interest, an animal might make a mall or festival appearance. Such is the case for Heffy, here visiting young admirers at St. Gregory's Fall Festival.

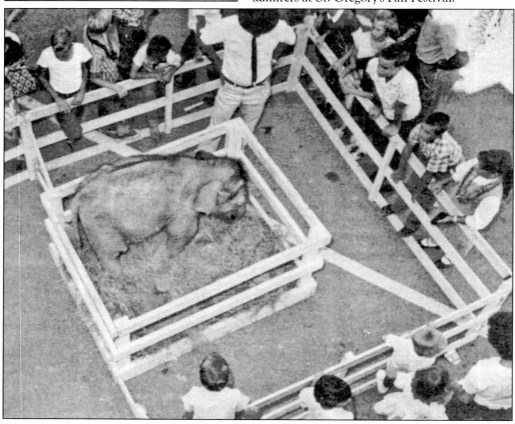

Shoppers at Park Central Mall crowd around Beau Brummel, the woolly monkey. Displayed on the walls are plans and sketches of the zoo. Society members distributed brochures explaining about membership in the Arizona Zoological Society. Park Central Mall was the first mall in Phoenix, opening in 1957. It now functions as a multiuse business park.

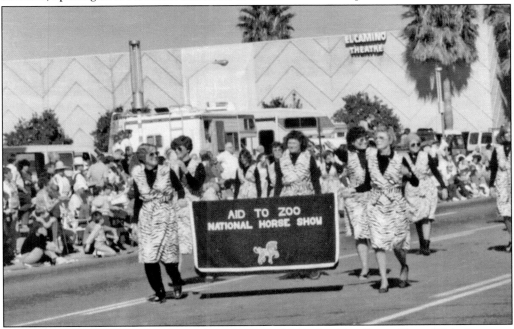

The auxiliary walked in a local parade to promote the Aid-to-Zoo Horse Show. This show was a major fundraiser for the zoo. In 1961, the auxiliary promoted building the new zoo all over town. It had Arizona Zoological Society booths at malls, festivals, and even home shows. It did everything it could think of to keep the public's focus on the new zoo.

The society was always seeking funds to get the zoo built. Along with the pennies from schoolchildren was a more formalized two-sided donor card. It gave donors a receipt for their tax deductions. It was a means of advertising as well. People remember who they give money too.

Grocery store shopping bags were printed with the slogan "Build the Zoo in '62." Milk cartons boasted the slogan, and department stores placed it in their ads. Civic groups and businesses took out full-page newspapers ads and brought radio and TV time.

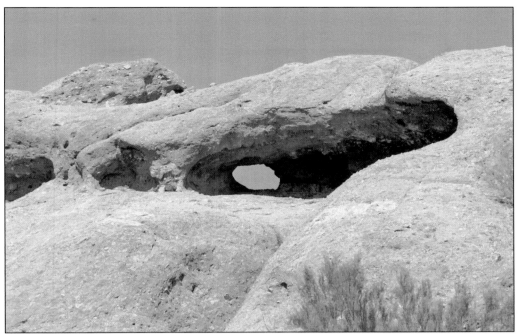

On January 31, 1914, Pres. Woodrow Wilson declared the 2,000-acre Hole-in-the-Rock location a federal property, naming it Papago Saguaro National Monument because of giant cacti and numerous prehistoric pictographs. In 1930, Papago Saguaro became the first national monument to be abolished by Congressional act. On April 7, 1930, it was re-designated an Arizona state park. The City of Phoenix was able to reopen the entire park by 1960. It took 17 months to get the park ready for public use. Names had to be sandblasted off rocks and debris removed from the ponds. (Author's collection.)

There was little funding for even basic preservation. The monument lacked sufficient funds to remove graffiti, and the namesake saguaro cacti were being stolen by the public for landscaping. During the Great Depression, Gov. George W.P. Hunt (Arizona's first elected governor) commissioned the bass fish hatchery to be built in 1932 as a Works Progress Administration (WPA) project and operated by the Arizona Game and Fish Department. In 1959, the City of Phoenix bought the 1,176 acres from the State of Arizona for $3,529.02 with the dream of turning it into a desert playground. (Courtesy of the Phoenix Public Library.)

Gov. George W.P. Hunt had a tomb built in 1931 atop a mountain in Papago Park for his wife, their daughter, and his wife's family. He was placed there after his death on December 24, 1934. It is a popular spot to visit and can be seen from the zoo. "Papago was a national monument that celebrated arid landscapes and the associated human and natural cultures. "At that time, it was on the edge of everything and not at the center of anything," according to Jeff Williamson, president of the Arizona Zoological Society. (Left, courtesy of the Phoenix Public Library; below, author's collection.)

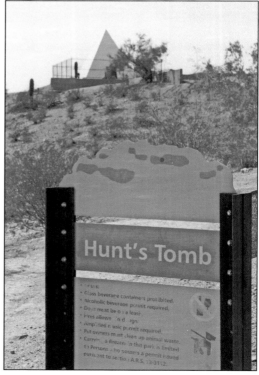

Two

THE ZOO IN '62
AND BEYOND

Before construction on the zoo even began, a membership drive was initiated. Over 1,000 memberships were sold, showing that the public had faith that it would get its zoo. School groups of all ages took up collections and held bake sales or car washes to purchase trees and plants for the barren zoo. In spite of all the publicity, there were signs that money was beginning to be a problem. The initial fundraising effort had fallen short of the proposed $2.1 million. Despite this, the zoo opened on time, as the society promised.

Just before the gates were opened, there had been a last-minute planting of hundreds of trees around the grounds. But it still looked bare. Only two exhibits were complete. When opening day arrived, William Orr and C. Tim Rodgers (society officers) arrived a few hours earlier to attend to one final task. They rushed around the grounds placing signs that read "Future home of the Elephants" and "Future home of the Giraffe." "We really weren't much of a zoo in those days," Orr admits, "but we had a wonderful collection of signs."

On November 21, 1962, Nancy Maytag and her board converged on the west end of the new bridge leading to the front gate of the zoo, where a crowd of over 2,000 waited. Despite Robert Maytag's objections, the board decided to name the new zoo the Maytag Zoo as a tribute to him. The zoo was now officially open but not financially out of the woods. Construction costs, especially the sewer and water lines and earthmoving, were more expensive than anticipated. Zoo officials watched as construction costs quickly ate up what they had thought would be comfortable reserves of capital.

They also realized that they had overestimated attendance. Having nothing to base attendance projections on, they had guessed too high. With Arizona's hot summers, attendance fell to a mere fraction of what they had hoped for. With the declining gate receipts, the zoo's financial situation became a crisis, and by fall, it was over $200,000 in debt.

The zoo would never have opened in the first place had it not been for its generous supporters. But there were signs that many Phoenix residents still expected someone else to pay. "Get the Maytags to pay for it!" was too frequently heard. Robert Maytag himself had anticipated this. What had been an innocent tribute, the board realized, was now a hindrance. In April 1963, the zoo was renamed the Phoenix Maytag Zoo; then in June, simply the Phoenix Zoo.

Work on the important task of digging and laying sufficient sewer and water lines proved not only to be difficult but also expensive. Just below the Papago Park's topsoil was a thick rock layer that made trenching time-consuming. But these were needed lifelines without which the zoo could not function.

To be sure that the roads and paths would be adequate for the crowds of expected visitors, the Navy Seabees and Marines and Army Reservists lent a hand. Many training missions were on zoo projects. Seen here is Company D, 9th Engineer Battalion, US Marine Corps Reserve from Phoenix. Working on this road's perimeter was not its only task. It also moved 1,500 yards of fill dirt along the zoo lake and carved a road using this 30-ton Euclid bulldozer.

Max Veber, public services director, and "Sandy" Horner (on backhoe), Nancy Maytag's eldest son, work extra hours to have everything ready for the zoo's big day.

Unbeknownst to the newly formed Arizona Zoological Society, another group in town had been meeting for over two years to talk about building a smaller zoo for children. It called its association the Children's Zoo Committee. It had negotiated with an architect and had some preliminary drawings done before it ran into funding problems. By late 1960, it was at a standstill. The two groups agreed to merge organizations. The Children's Zoo was the first part of the zoo built.

The Arizona Zoological Society

requests the honor of your presence

at the opening day ceremonies of the

Zoological Park

on Wednesday, the twenty-first of November

at ten o'clock in the morning

Papago Park

Phoenix, Arizona

After her husband's untimely death in 1962, Nancy proved to be an effective leader. "It was a period of delightful, enthusiastic chaos," recalled Nancy Maytag Love. "We were absolute beginners. We didn't have any idea what we were getting into, but our enthusiasm and the certainty that we were building a great zoo carried us through every challenge we faced." She continued to lead the effort to build the zoo. At 10:00 a.m. on November 21, 1962, everyone involved with the zoo's creation converged on the west end of the new bridge leading to the front gate. Brief speeches were made by Sen. Carl Hayden, Gov. Paul Fannin, Phoenix mayor Sam Mardian Eugene Pulliam, Walter Benson, and Nancy Maytag to a crowd of over 2,000.

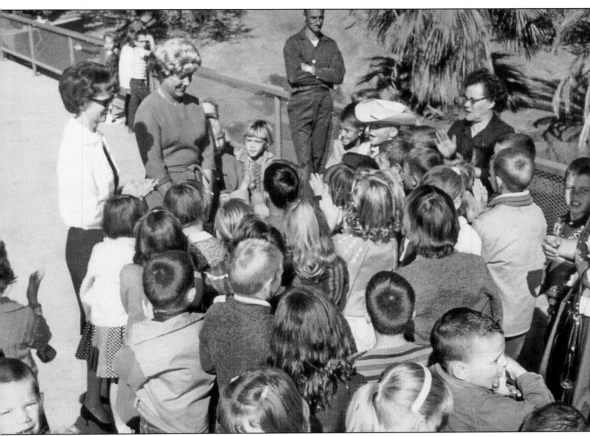

Nancy Maytag greets a bunch of anxious children on opening day. They seem as excited about their zoo opening as the board was. It was appropriate that there were so many children since the Children's Zoo was one of the two completed exhibits ready for opening day.

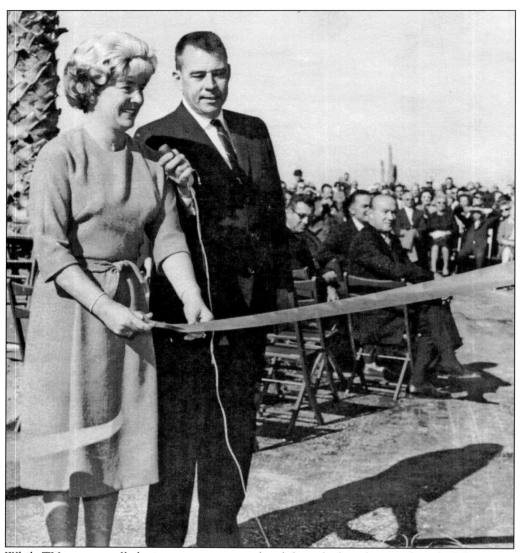

While TV cameras rolled, pictures were snapped and the radio broadcasters described the action as Nancy Maytag cut the ribbon. With her board, she watched as the first visitors entered the officially opened Maytag Zoo. The board had decided it would be a tribute christening the zoo in Maytag's honor in spite of the objections Robert Maytag voiced about naming the zoo after him or the Maytag family. He argued this would not generate the public's support. While the zoo was to be considered private, it belonged to the general public; it was their zoo.

Guest Ticket

Phoenix Maytag Zoo

Admit One

Good Until_____

Arizona Zoological Society

On November 21, 1962, a proclamation by Arizona governor Paul Fannin opened the celebration of what the he called "a major cultural step for Phoenix and the people of the state of Arizona." The occasion was Zoo Day, marking the formal opening to the public of the Phoenix Zoo, the first zoo built in the state.

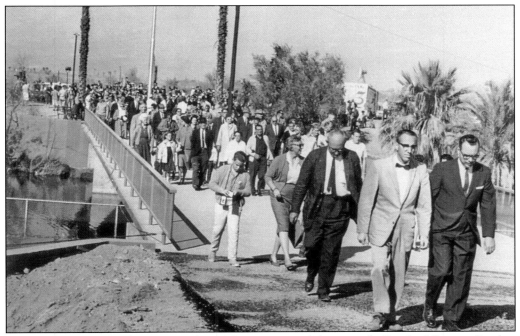

The next day was Thanksgiving, and 10,000 visitors toured the grounds. On the following Sunday, the attendance reached 12,041. By the end of the first week, the zoo saw 38,000 people through its turnstiles. By the end of the year, attendance was 100,000. The 700 mammals, birds, and reptiles that had been the object of all the attention over these several days did very well under zoo conditions. But there were a few stone-throwing incidents reported, requiring the posting of an attendant in some areas to protect the animals.

Robert E. Maytag Sr. was the man behind the zoo but did not live to see his dream become a reality. Other changes were taking place. Building the zoo had been Robert Maytag's dream. After his death, Nancy Maytag vowed to see the dream fulfilled. And she did. However, by the spring of 1963, she had begun making plans that were not totally involved with the zoo. In October, she submitted her resignation. An era had come to a close.

Of the more than 2,000 visitors, three-year-old Paula Hazelton shot underneath the turnstile to become the zoo's first official customer. All grown up, she is now Paula Hazelton Acer, DVM (shown here with her father). Her father, Ed Hazelton, took her to the zoo on opening day. Dr. Acer was a special guest of honor at the zoo's 40th anniversary celebration. Acer, now a veterinarian in Kingman, Arizona, said, "I knew when I was very young that I wanted to be a vet."

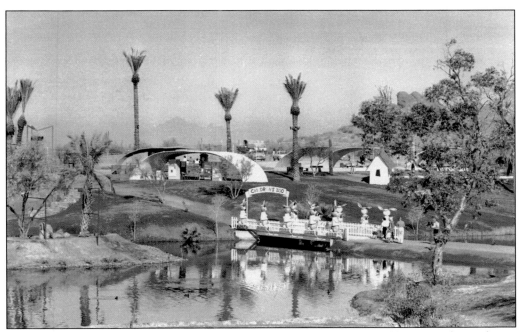

On opening day, an awesome land waited for children and grown-ups alike. It was located near the entrance. It was the Children's Zoo—a place with baby animals, a petting zoo, chickens, goats, and even a baby elephant. The walk took visitors by one of the lakes located inside the zoo grounds.

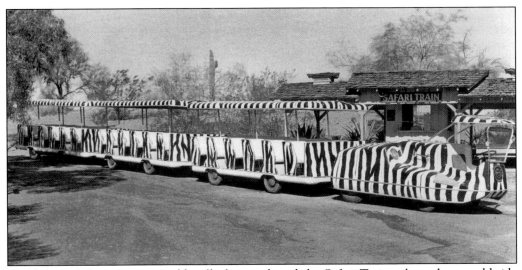

Children and their parents could walk there or board the Safari Train, where they would ride past the bird exhibit and over the Bunny Bridge. A Safari Train tour was 50¢ for adults and 25¢ for children.

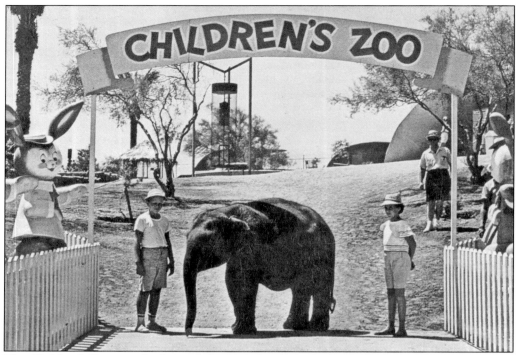

The Children's Zoo was the first exhibit completed. On opening day, visitors were greeted by Heffalump, the baby Asian elephant. Heffalump (or Heffy) was named after the elephant in the Winnie-the-Pooh story. She was one of the smallest elephants brought to the United States. Here, the children could feed Heffy and Sassafras (another baby elephant) and even llamas.

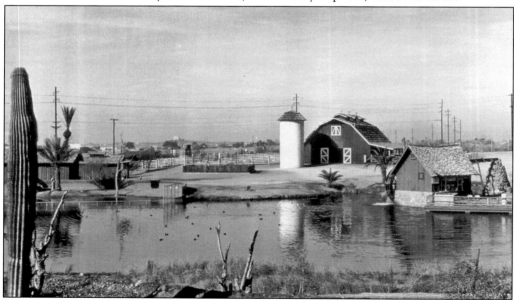

The Big Red Barn has a real hayloft and measures 36 by 50 feet. There are also two corrals measuring 50 by 50 feet. The chicken yard has seven runs and displays seven kinds of barnyard chickens, and a millhouse has a large waterwheel.

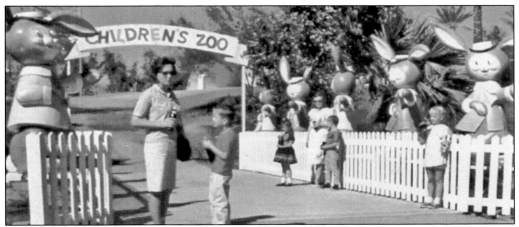

The Bunny Bridge was the entry to the Children's Zoo. It got its name from the two rows of five-foot-tall fiberglass bunnies. The bridge was a landmark at the zoo since its opening, but after 15 years of exposure to the Arizona sun, the rabbits posed a constant repair problem. In 1977, a public outcry arose when it was learned that the bridge and bunnies were going to be replaced by a shady resting spot for zoogoers. Local radio station KDKB threatened to pull its support for the zoo and all zoo fundraisers. The threatened closure made the front page of the newspaper. Parents and children wrote protest letters. Feeling public pressure, the board voted to reopen the bridge, stating "We're here to make people happy. If the Bunny Bridge makes people happy, then we're happy."

At the far end of the Children's Zoo was the baby animal nursery. Most zoos have special nurseries, but the Phoenix Zoo was one of the few where one could actually watch animal infants. Through the big glass windows, visitors could watch as specially trained nurses cared for the zoo babies. Zoo nursery babies were quite often under the care of zoology students from the nearby Arizona State University who were furthering their studies. The Children's Zoo featured fun animal trash containers and drinking fountains.

The other exhibit that was ready on opening day was the Arizona Exhibit. Publisher Eugene Pulliam pledged $130,000 for its construction. This show of support helped keep the momentum going. Thanks to him, the state news media continued to follow the story of the Phoenix Zoo closely. The exhibit measured 134 by 160 feet. It featured a walk-through aviary large enough for trees.

Eugene Pulliam kept the public's eye focused on the zoo. If they were not visiting the zoo, they were being kept informed on what was happening at their zoo. Thanks to him, the state news media continued to follow the story of the Phoenix Zoo closely. The press covered every zoo birth or improvement event.

Building the zoo was one goal accomplished, but keeping it open was another thing. The hot summer months saw attendance drop, and gate revenues were important to a privately funded zoo. With Nancy Maytag's resignation from the Arizona Zoological Society, a banker named Earl Bimson stepped forward. His strong leadership over the next 13-year chapter of the zoo kept it from closing. Bimson negotiated with creditors, and by 1965, the zoo was back in the black.

In the 1980s, the zoo did some major remodeling with a new entrance complex that included a gift shop. The zoo placed the exit on the other side of the gift shop. While zoo visitors departed, they had one more opportunity to make a T-shirt, toy, drink, or souvenir purchase.

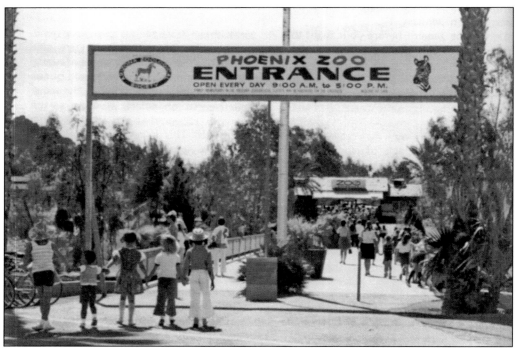

The first zoo entrance in 1962 comprised an old barn from the back of the property that was cut in half—a big contrast from the zoo's entrance today. The walk over the bridge is paved in bricks engraved with donors' names. Admission is purchased before crossing over the bridge. The entrance is often decorated to reflect the season or showcase any large events the zoo is sponsoring. Just before entering, visitors are given the opportunity to have a souvenir photograph taken. They can purchase the photograph at a booth just inside the turnstiles. (Below, author's collection.)

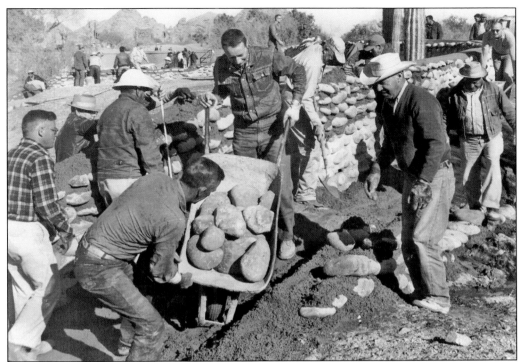

More than 75 employees of the Salt River Project's irrigation construction and maintenance division provided labor and materials to the Galapagos tortoises' permanent enclosure. Over $450 and nearly 1,000 man-hours were contributed to the tortoise exhibit. The Salt River Tribal Council donated 75 yards of smooth, rounded boulders.

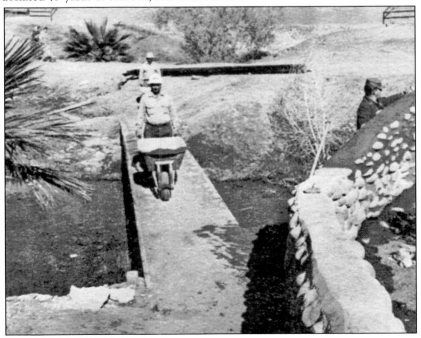

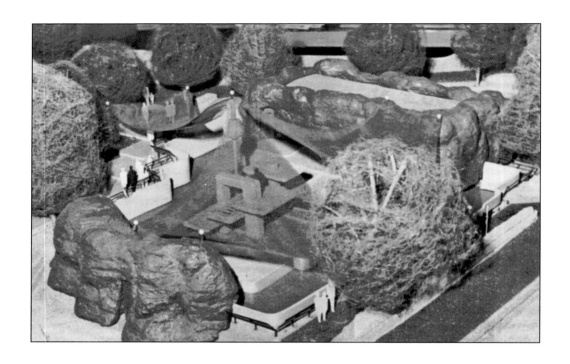

The Phoenix Zoo has had invaluable help from ASU's zoology, engineering, and architecture departments. This was beneficial in helping plan the zoo's future. Most of the plans for the gorilla moat were designed by ASU facility and students. The plans included night quarters, a keeper's workroom, an animal exhibit area, enclosures, and sun control areas for the gorillas in addition to a windbreak, spectator gallery, and wheelchair gallery. All of this was a great savings to the zoo. ASU also worked on the elephant exhibit. Shown above is the mock-up of the gorilla exhibit in 1970.

Money for this exhibit was provided by the proceeds from the 1986 Aid-to-Zoo Horse Show. This horse show was the auxiliary's biggest annual fundraiser. The exhibit had high platforms for the gorillas to climb. There are special platforms for viewers to match the animals' heights and allow a better view of them. There are also heating coils embedded in the concrete for cooler weather, three air-cooled and -heated night houses, and a shallow pool for the gorillas to splash in.

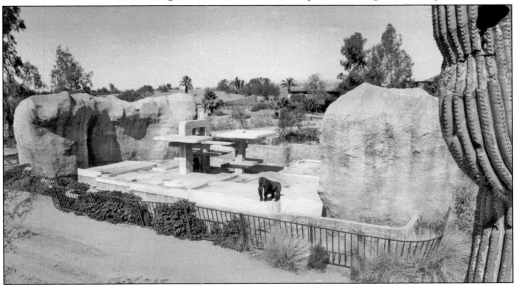

The gorilla exhibit was dedicated on the morning of June 16, 1974, by Earl Bimson, president of the Arizona Zoological Society. It was paid for by the auxiliary's fundraising over the course of three years. For the 1970s, this 2,400-square-foot exhibit was unique. At the time of the dedication, the exhibit housed Hazel, the zoo's nine-year-old, 350-pound female gorilla, and her mate, Baltimore Jack. As if on cue when the doors of the night houses were opened at the end of the ceremony, Hazel raced out into the open area and amazed the crowd. Several commented that she looked much bigger without bars surrounding her.

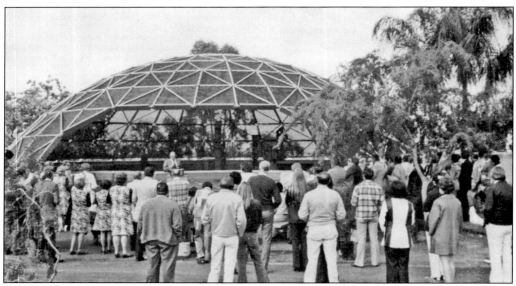

The orangutan exhibit (opened in April 1975) was 2,800 square feet with climbing structures for the big apes. It was covered in a geodesic dome to protect the apes and their human visitors from the weather. The conceptual design was by Wayne Homan and Alex Taylor from the zoo. The architects were Drover, Welch, and Lindian. J.R. Porter Construction Company built the exhibit. Funds came from the auxiliary's Aid-to-Zoo Horse Show and the Phoenix Rotary 100. This exhibit was the forerunner of a large development plan that included more animal exhibits and new power lines, roadways, sewers, and water lines. The plan also included a new animal food preparation and storage area, Safari Train station, snack bars, and entrance complex. All this growth was accomplished through donations from private citizens, business organizations, and civic groups. In typical zoo fashion, the ribbon-cutting ceremony at the 1975 opening of the orangutan exhibit featured not a ribbon of satin but one of bananas. Earl Bimson was assisted with the appealing task by representatives from various donor organizations.

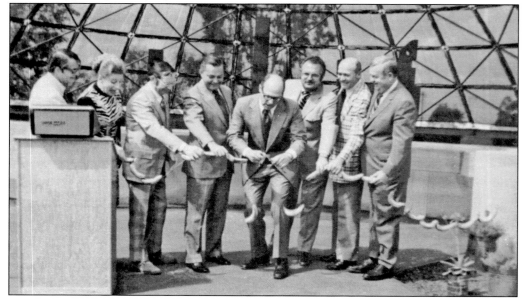

The new Animal Care Center was constructed with funds from the Aid-to-Zoo Horse Show. Construction of the new center used up all the funds for the project, leaving it structurally complete but unfinished on the inside. Central Arizona Veterinary Medical Association stepped in and undertook the interior furnishings. This began a long period of sponsorship at the Phoenix Zoo. The association raised $10,000 for medical and surgical equipment. Over the next 12 years, the veterinarians' association would make further contributions to bring its total over $20,000.

In 1969, the students of Mesa Junior High undertook bake sales and car washes and raised $2,700 for the South American bird exhibit, located near the administration building.

47

Isle of the Tiger exhibit opened in 2016. It is the final jewel of the A World Class Zoo For A World Class City Capital Campaign. The zoo's budget for the project was $2 million. This larger habitat replaced an existing, functional habitat. The new exhibit is 16,000 square feet of space featuring Sumatran architecture and expansive views. Isle of the Tiger also includes a 2,000-square-foot holding building with six den areas, two of which are mother-cub dens, and two off-exhibit yards. The dens include heated and cooled floors along with independent rolling shutters for ventilation and cooling purposes. This exhibit is located across from Land of the Dragons, the Komodo dragon habitat, and next to the Asian elephant exhibit.

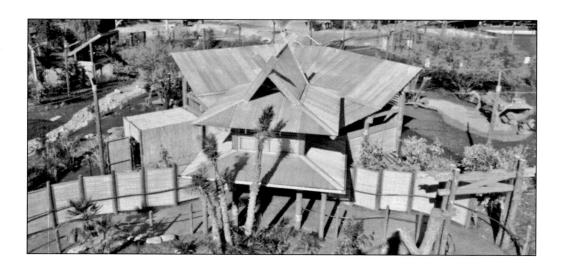

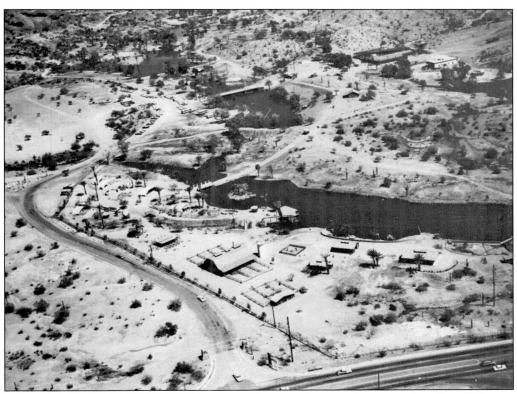

This aerial taken in 1962 of the zoo's entrance shows an absence of greenery. See what difference a decade can create. Taken in 1972, the photograph below shows that 10 years of heavy planting converted the area into a jungle of plants and trees. Certain plants did not do well during the hot summers, but this was remedied by the installation of bubblers and sprinklers.

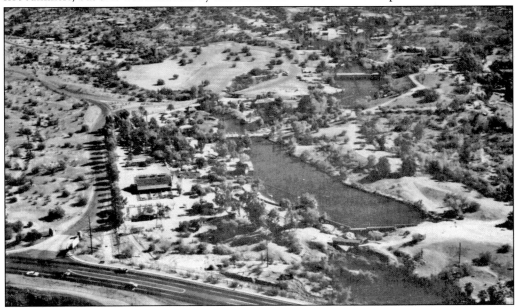

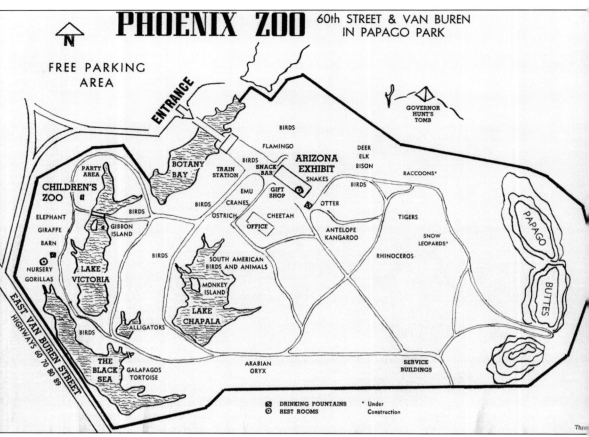

PHOENIX ZOO

60th STREET & VAN BUREN
IN PAPAGO PARK

N

FREE PARKING AREA

ENTRANCE

GOVERNOR HUNT'S TOMB

BIRDS

FLAMINGO

DEER
ELK
BISON

RACCOONS*

BOTANY BAY

TRAIN STATION

BIRDS

SNACK BAR

ARIZONA EXHIBIT

PARTY AREA

SNAKES

BIRDS

CHILDREN'S ZOO

EMU

GIFT SHOP

CRANES

OTTER

ELEPHANT

BIRDS

OSTRICH

CHEETAH

OFFICE

TIGERS

GIRAFFE

GIBBON ISLAND

ANTELOPE KANGAROO

SNOW LEOPARDS*

BARN

NURSERY

BIRDS

SOUTH AMERICAN BIRDS AND ANIMALS

RHINOCEROS

PAPAGO

GORILLAS

LAKE VICTORIA

MONKEY ISLAND

LAKE CHAPALA

BUTTES

BIRDS

ALLIGATORS

EAST VAN BUREN STREET
HIGHWAYS 60 70 80 89

THE BLACK SEA

GALAPAGOS TORTOISE

ARABIAN ORYX

SERVICE BUILDINGS

DRINKING FOUNTAINS
REST ROOMS

* Under Construction

This is one of the first guide maps handed out to zoo guests. Over the years, the map would fill in as the zoo filled out. It would also be in color and offer additional information about the zoo, such as operating hours and special exhibits.

To maintain local interest and support, the zoo began to offer birthday parties and school tours. The zoo offered parents the most amazing bargain in birthday parties. The price for a party of 11 was $15 and included the reservation of one of the covered ramadas with tables and chairs. Each guest received a plastic toy replica of one of the animals in the zoo, while the birthday child was given a large plastic elephant. Everyone was served cake and ice cream. The cake was large and decorated with the child's name and small toy zoo animals. School tours invited teachers to bring their entire class to the zoo free of charge. Guides were provided at no cost to the schools. Lunches were available at 45¢ each with milk and 35¢ without milk. Schools made use of this program. Their participation helped boost the 1967 attendance by some 50,000 people over that of 1966.

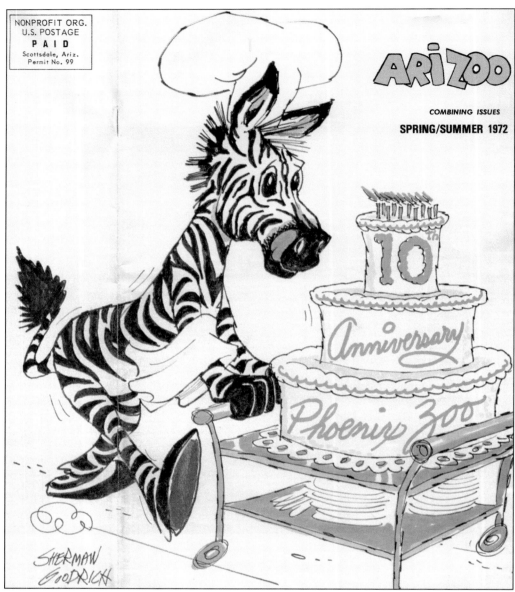

ARIZOO

COMBINING ISSUES

SPRING/SUMMER 1972

SHERMAN GOODRICH

When the zoo hit the decade mark, it commissioned Sherman Goodrich to illustrate the cover of *Arizoo*, the membership magazine. Goodrich is a commercial animator and cartoonist whose work has appeared in the *Saturday Evening Post*, *Good Housekeeping*, and almost every other major magazine.

When smoking was more fashionable, the zoo took advantage and used matchbooks as an advertising tool. They were in a way a pocket guide to Phoenix's new zoo. The matchbooks gave the zoo's hours of operation and admission fees and even provided a handy map showing where it was located.

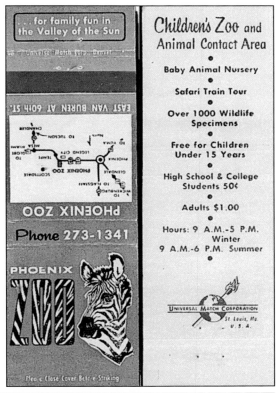

LouLou, a 20-year-old southern white rhinoceros who loves to wallow in water and mud, has the exhibit to herself for now. The zoo anticipates receiving another rhinoceros sometime in the future. Paige McNickle, senior hoof stock keeper at the Phoenix Zoo, said LouLou weighs approximately 4,500 pounds and her daily diet consists of half a bale of Bermuda hay, some Sudan hay, and four and a half gallons of pellets. "We modified the exhibit because she is a lot younger than our previous rhinos, so we wanted to make sure she had a lot more things to interact with," McNickle said. "Rhinos are one of the most endangered species and she is representing a species that is in critical peril." McNickle said that in South Africa alone, three rhinos lose their lives per day because of poachers illegally seeking rhino horns. (Author's collection.)

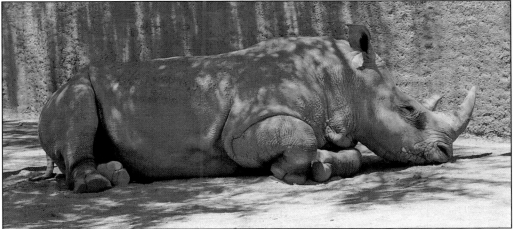

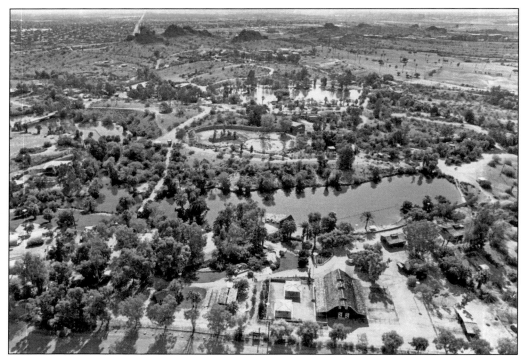

This is a 1980s aerial shot of the elephant exhibit and refurbished Children's Zoo. It also shows almost 20 more years of tree and shrubbery growth. During this time, the zoo also divided itself into four main themes or trails.

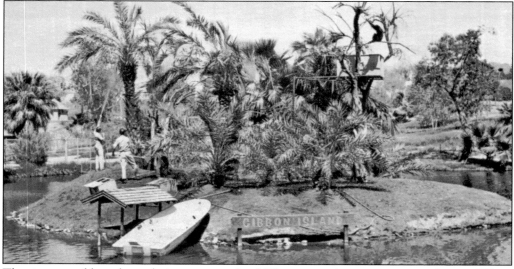

The siamang gibbons have their very own island. The surrounding water acts as a barrier. When keepers need to provide food or when it is time for checkups, they row a boat out to the island.

The millhouse was one of the first exhibits on opening day in the Children's Zoo and is considered the most picturesque exhibit. The millhouse is 16 by 17 feet, and it features a waterwheel that is 11 feet in diameter. Still at the zoo, the millhouse is located in what is now called Harmony Farm and offers great lakeside views. (Below, author's collection.)

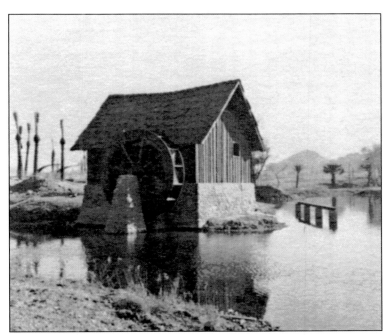

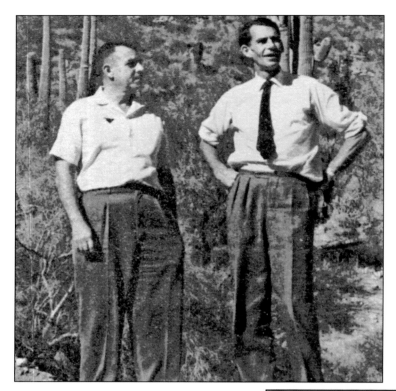

Robert H. Mattlin (left) and Maj. Ian Grimwood, Kenya's chief game warden, are seen here discussing the site for the Arabian oryx "World Herd." The Phoenix Zoo was chosen because of the climate and the well-qualified zoo personnel.

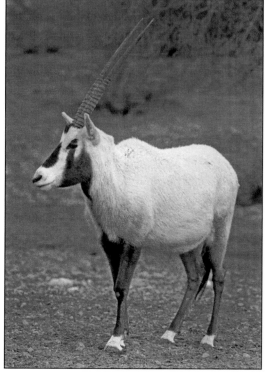

Arabian oryxes are poached for their sought-after horns. Their horns are a little over two feet, and looked at in profile, the animals look like the mythical unicorn. The local belief was that the horns of an oryx gave a person vigor and the ability to go for long periods of time without water. Oryxes are some of the world's rarest animals, and they are in trouble.

In September 1975, the Phelps Dodge Corporation donated the Zoomobile, a specially equipped van used to carry animals to schools in rural areas of Arizona. Phelps Dodge provided the van and paid a driver's salary, while the Phoenix Zoo chose the driver and the animals. The Zoomobile, with its animals, would drive off to remote areas of Arizona. This program won an Outreach Award in 1978 from the American Association for Zoological Parks and Aquariums (AAZPA)—now the Association of Zoos and Aquariums (AZA)—marking the beginning of the Phoenix Zoo's legacy of strong outreach programs. The Zoomobile program has touched the lives of more than 1.5 million kids. Children's programs give youngsters the opportunity to experience the excitement, patience, and hard work that animal care requires.

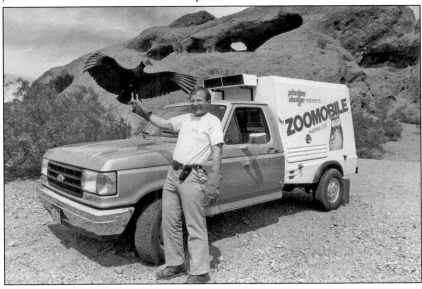

Rafiki was born in the 1970s. He was the son of mother Freckles and father Hatari. When he was born, Rafiki stood five and a half feet tall and weighed 120 pounds. There was a contest to find a name for him. Bobby Adams Jr. was the winner and appeared on the daytime children's television *Wallace and Ladmo Show* to get his prize. He came up with the name *Rafiki*, which means "friend" in Swahili. Bobby's winning name was selected from over 1,000 entries. He was awarded a tall toy giraffe of his own (seen in background). Zoo public relations director Bryant Arbuckle made the presentation. From left to right are Bobby, Ladmo (show cohost), Arbuckle, Wallace (cohost), and the show's antagonist, Gerald (played by Pat McMahon). *The Wallace and Ladmo Show* had the distinction of being the longest-running same-cast-ensemble children's show in television history. The show ran for over 35 years. Both Alice Cooper and Steven Spielberg made guest appearances on the show.

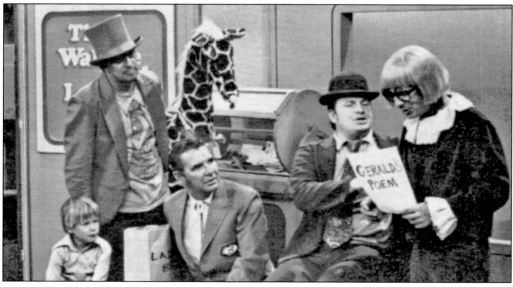

On August 31, 2015, a powerful monsoon tore through the zoo. The storm uprooted and destroyed 70 trees and caused significant damage to several animal exhibits, public trails, and behind-the-scenes areas. Fortunately, no animals were injured or escaped. The damage forced the zoo to close for an unprecedented three days while dozens of staff and volunteers, as well as outside agencies, made repairs. Downed trees were hauled off and debris cleaned up. Restoration continued for months. This would not be the only time this would happen. Monsoon season in Phoenix often has destructive storms.

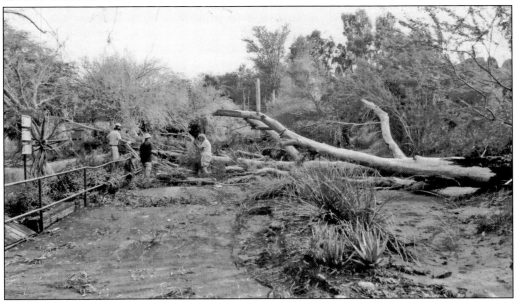

The zoo supplied photographic backdrops for various groups. In the 1960s, the Arizona State University Players used the zoo grounds extensively for location photographs. These photographs were then integrated into the stage presentation of *Bye Bye Birdie*.

The zoo is very green. It composts more than 400 tons of organic waste (animal manure and plant material). In addition to the composting bins, the zoo has implemented several water retention programs. In 2013, the zoo set the goal of reducing consumption by 15 million gallons of water per year. It also has an inkjet cartridge recycling program. Guests bring the cartridges to the zoo and place them in special recycle bins. This is not only a green project for the zoo but also a fundraiser. The zoo of 1962 did not utilize solar power, but today, solar cells can be spotted around the zoo. (Author's collection.)

Three

THE PHOENIX ZOO

AUXILIARY

Though contributions had reached more than $1 million, there were concerns about reaching the projected total of $2.1 million by the opening date of November 21. Nancy Maytag, in a series of media interviews, urged residents to support their zoo. She gently reminded them it must be the zoo they wanted, not the one the Maytag fortune would force on them.

Maytag helped raise money for the fledgling zoo by founding the Phoenix Zoo Auxiliary, an organization that remains one of the zoo's strongest partners. Her goal was "to help out wherever we can" and to do "a little" fundraising.

Since its inception, the auxiliary has contributed over $3 million in funding to various projects and continues its proud tradition of ongoing support of the zoo in numerous ways. The first Phoenix Zoo Auxiliary was made up of many of Phoenix's movers and shakers. Through the years, auxiliary members have undertaken numerous projects, from staging horse shows and gourmet barbecues to stuffing envelopes and helping care for baby animals during a time when the zoo could not afford professional staff. In 1970, the auxiliary expanded the alligator exhibit, bought a male gorilla and a giraffe, and funded the long-range planning study that would determine the zoo's growth over the next decade. In 1971 and 1972, the auxiliary also paid for the extensive remodeling of the lion and tiger exhibit. Other fundraisers included Zoo-B-Que (an Arbor Day event), the Great Adventure Hunt (a timed scavenger hunt and dinner), Zoo Sounds (a concert and dinner), Aid-to-Zoo travel, and ZooFari, a unique gourmet tasting event born in 1988.

The auxiliary's contributions during the first 10 years totaled more than $300,000. While a cornerstone of the auxiliary was fundraising, Nancy Maytag had said, "Help out wherever we are needed." So it did. Some of the members led guided tours of the zoo, some assisted in the baby animal nursery or the petting zoo or worked in the office and gift shop. Others went so far as to house baby animals in their homes while they waited for their exhibits to be completed. Duchess, the zoo's orangutan, originally lived with Betty Bimson and her family when she was a youngster.

From its first days as a service organization to the zoo, the auxiliary's members have volunteered in other capacities, not just at the zoo. They have helped at the Parada del Sol and Fiesta Bowl, donated gifts to needy families, hosted school groups of homeless children, and fulfilled the zoo's wish list.

The Phoenix Zoo Auxiliary is the zoo's oldest volunteer fundraising organization. It was founded in 1961, a year before the zoo opened. The auxiliary adopted zebra outfits, which became its trademark. Volunteers have had various types of uniforms, including a zebra-striped dress that fell just below the knee. Today's auxiliary members, numbering 107, have kept the zebra-stripe motif for their uniforms, wearing vests.

The auxiliary held a fashion show in the Peace Pipe Room of the Camelback Inn. This was the first event open to the public for the newly formed auxiliary. Live and at times caged animals supplied the set dressing. New York fashion designer Teal Traina showed his summer collection. Though the auxiliary's Aid-to-Zoo Horse Show was financially more successful, its Fall Fashion Show and Luncheon, first held in 1962, was a long-running staple of the fashion show season. It earned monies toward many projects until the final show in 1993. The zoo is now a popular venue for weddings. Couples can have an elegant ceremony in the wild—but sorry, no animal ring-bearers.

Ann Lee Harris, auxiliary president, was able to persuade Paramount Pictures to hold the world premiere of the new Howard Hawks movie *Hatari!* in Scottsdale as a benefit for the zoo. On June 7, 1962, the star of the film, John Wayne, and others from the cast arrived for the festivities. The premiere raised $8,000, used to purchase Hatari, a baby giraffe, and his female companion, Freckles. Pictured here are John Wayne and Nancy Maytag.

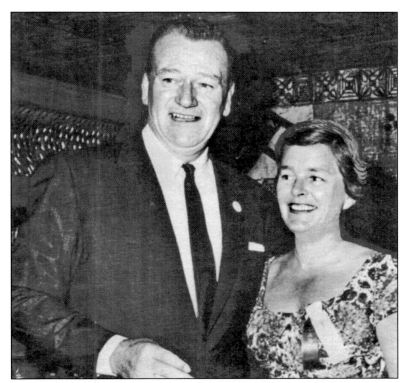

Hatari became an instant success in the Children's Zoo. The fence barely came to his knees, and he was constantly surrounded by kids who fed him cereal from the vending machines. He always produced gasps and gales of laughter as his long tongue curled around his treat. *Hatari* is Swahili for "danger."

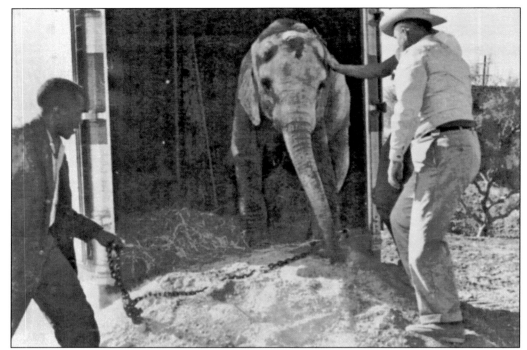

Elka, one of the three elephants starring in the film *Hatari!*, was brought by truck from the Lincoln Park Zoo to her new home at the Phoenix Zoo. She made it just in time for opening day.

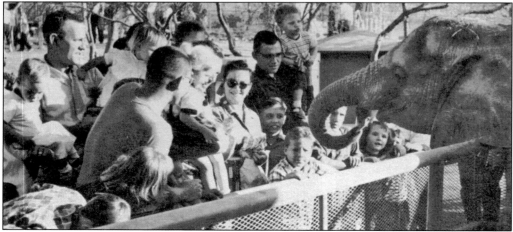

Elka was a four-year-old African elephant. She seems to enjoy watching all the humans confined by the "people fence."

In March 1963, the auxiliary sponsored its first Aid-to-Zoo National Horse Show at the Arizona Biltmore Hotel. There were 220 exhibitors showing 350 horses and ponies. When opening day arrived, over 1,000 people were in attendance. All the proceeds from the five-day event totaled $12,000. According to *Horseman's* magazine, the Aid-to-Zoo show was considered the "most glitteringly successful of the indoor charity shows."

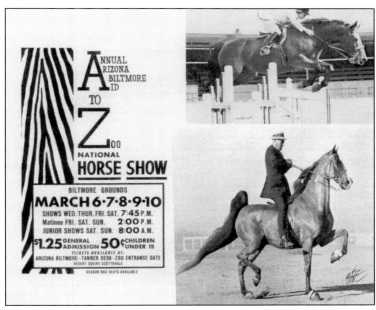

Ethel (Mrs. Kemper Sr.) Marley, one of the show's past chairs, stated, "Heaven knows there are easier ways to raise money. A charity ball would be a snap. But a national horse show is a contribution to the community [and] an attraction Arizona didn't have. We're providing an opportunity for the public to see some of the finest stock in the nation." At least 50,000 volunteer hours are worked by 125 members of the zoo auxiliary per show. Proceeds from these horse shows paid for Ruby the elephant's new quarters and a giraffe, to name a few of the good works the auxiliary's fundraising accomplished.

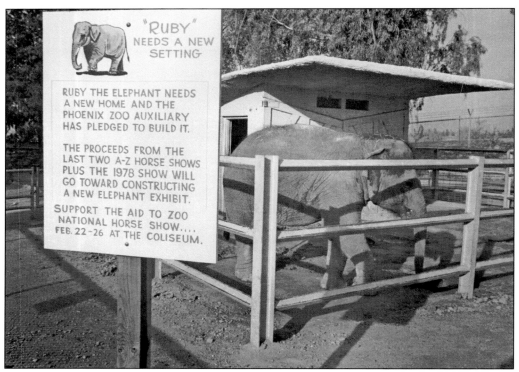

Leo the lion was not the only animal leaving in tight quarters. Ruby the Asian elephant was outgrowing her home too. Ruby was born in Thailand and was shipped to the Phoenix Zoo in February 1974, when she was about seven months old. Initially, her roommates were a goat and some chickens, but she had no elephant companionship for a few years. The proceeds from 1976 to 1978 from the zoo's big fundraiser, the Aid-to-Zoo Horse Show, were used to create Ruby's new complex.

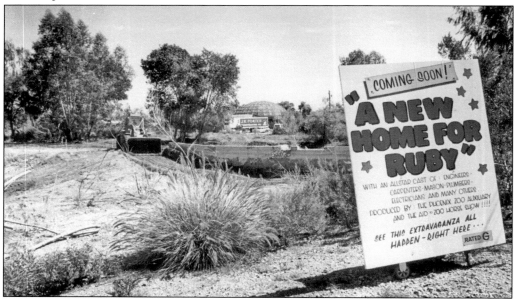

Save Leo the lion! On a wholesome diet, Leo, the abandoned, malnourished lion, quickly recovered, but there was still the problem of housing him. For the time being, until a proper exhibit could be built, Leo would have to live in a cramped cage. The zoo began a drive to raise $16,000 for Leo's home. Widespread sympathy was generated but not enough money. By the end of 1963, only $2,000 had been raised, mostly collected by schoolchildren. Finally, in May 1964, a full year after the drive had begun, radio KRIZ disc jockey Ron Edwards took on the cause. He lived for 10 days in a cage adjoining Leo's and broadcast every 15 minutes on the lion's behalf. Edwards brought the total up to $10,000. On New Year's Day, Leo was released from his cramped cage and entered his new, spacious home complete with palm tree and a swimming hole—a home fit for the king of the jungle.

To encourage membership, the zoo offered special entrance days and events for members only. This is something the zoo still does. It offers after-hours events, special entry times, and discounts in the zoo. Membership and gate fees are a primary source of revenue for this privately funded zoo.

A Phoenix municipal bond election in March 2006 provided $2 million to a zoo project, marking the first time the zoo received public funds. On June 8, 2006, then zoo director Jeff Williamson announced a major fundraising drive over the next 10 years to update the zoo's infrastructure and many of its aging exhibits. The zoo needed to raise $70 million to complete the project. In 2009, a shorter-term goal was to raise $20 million by 2012 to pay for a number of improvements that are already under way. There is still a way visitors can feed the animals, and that is by putting donations into these donation stations. (Author's collection.)

One of the fundraisers the zoo did was to give the public a chance to purchase an engraved brick. The zoo would get the proceeds, and the donor's brick would be installed on the main walkway at the entrance to the zoo. (Both, author's collection.)

The Endangered Species Carousel at the zoo has 33 distinctive animals. It is designed to make visitors aware of animal species that are in danger of extinction. A carousel animal's life expectancy is an average of eight years before it is replaced by another animal. These handcrafted creatures are also available for adoption as a zoo fundraiser. Adoption is for the life of the carousel animal. (Author's collection.)

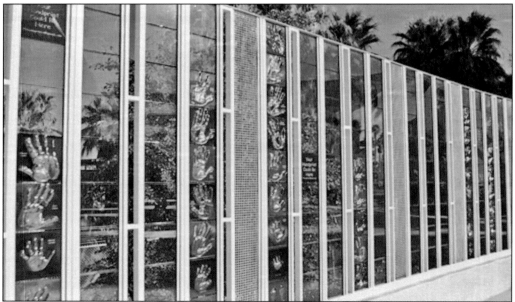

The Handprints in Glass donor wall is the first wall of its kind in the country. At the entrance oasis, the wall features the handprints of those who donated. The sun shines through the wall, highlighting all the various colors. Proceeds from the wall will help build the 500-seat amphitheater on the zoo's Nina Mason Pulliam Children's Nature Trail. The amphitheater will feature lakeside views and special holding areas for animals.

Four

FOUR TRAILS AND MORE TO EXPLORE

A visit to the Phoenix Zoo opens a world of discovery. For over 50 years, the zoo and its animals have amazed guests from across Phoenix as well as visitors from other states and countries. The zoo offers adventures like no other place in Phoenix. One of the nation's largest nonprofit zoos, it provides experiences that inspire people to care for the natural world—their world. Visitors can gaze upon huge elephants, tall giraffes, and the majestic tiger. They can enjoy the antics of the orangutans or squirrel monkeys. Where but the Phoenix Zoo can one feed a giraffe or ride a camel? The Phoenix Zoo has four major themed areas, or "trails," where visitors can experience exhibits representing different areas of the world and their native wildlife: the Arizona Trail, the Africa Trail, the Tropics Trail, and the Discovery/Children's Trail. There are 17 venues within the zoo, making it a popular location for weddings, meetings, reunions, company picnics, and even dreaded corporate team-building events. Guests can ride the Safari Train with a narrated tour, eat at cafés, visit the monkey village, or experience Stingray Bay. The Phoenix Zoo Conservation Center allows guests to see some of the conservation efforts the zoo is striding towards.

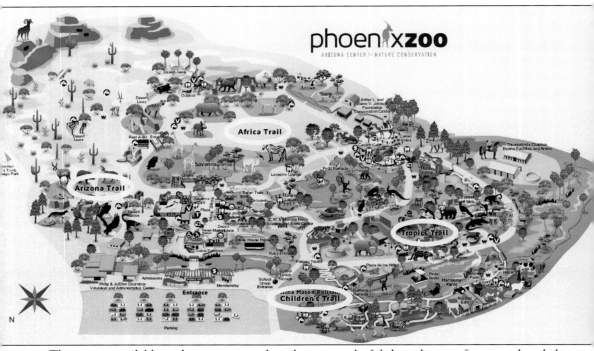

The map is available at the entrance and is a lot more colorful than the very first maps handed out to guests. Laid side by side, the maps also tell the story of the Phoenix Zoo's growth.

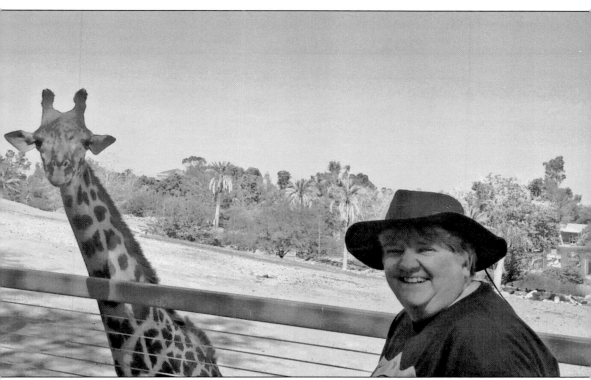

The Africa Trail showcases many of the most popular animals in the world. It takes up the largest part of the zoo. Here, visitors will find the zebras, ostriches, and giraffes, to name a few animals. At the giraffe encounter, the author did some research on the proper way to feed them. Their tongues roll out like a red carpet to gently snatch the offered treat. This is as interactive as a guest can get with the wild residents of the zoo. (Author's collection.)

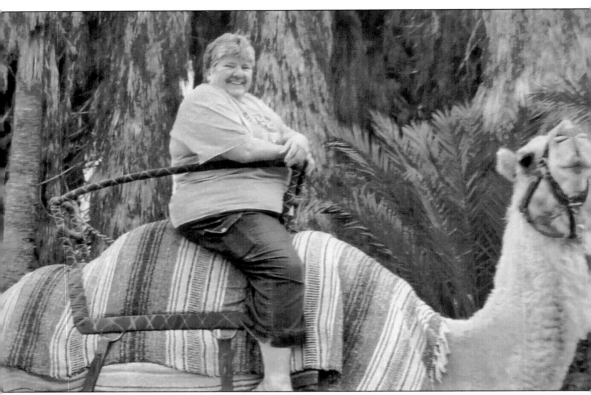

The author's research continued at the camel rides. As of 2012, the camel encounter, near the main lake, has provided more than 76,000 rides to children and adults each year since 2008. Nearly 50,000 guests have visited the giraffe encounter. (Author's collection.)

The zebra and giraffe exhibit was part of the new construction program for 1965–1966. The cost of $36,000 was underwritten by the auxiliary. The ladies raised the funds with proceeds from the Zoo-B-Que and the Aid-to-Zoo Horse Show. Designed by Jack Corriere of Phoenix, formerly with the San Diego Zoo, the giraffe and zebra exhibit took some 160 cubic yards of concrete, another 1,200 sacks of cement, four tons of rebar, 2,600 square yards of metal lath, and three months of work to complete, with over 600 plants including 35 mature palms to landscape. Man-made rock formations hide the holding pens and night houses. The zebras and giraffes roam free, separated only by a waterfall-filled pool. A dry, almost six-foot-deep moat separates the animals from their viewing public. The step-down moat had been used infrequently to hold giraffes, but this was believed to be its first use for zebras at any zoo. Today, the species are still separated, but the area has grown. The giraffes now share a huge exhibit with ostriches and Watusi cattle. The giraffes are also part of the giraffe encounter, where guests may purchase treats and, under supervision, feed these long-necked, majestic creatures. (Below, author's collection.)

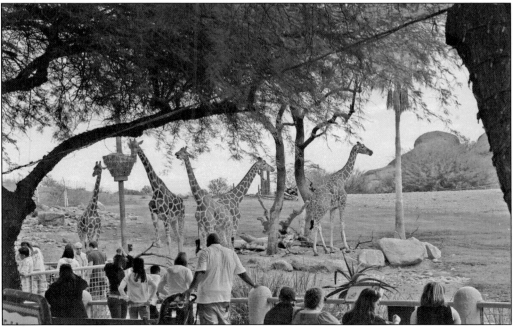

The Tropics Trail has two parts: the inner trail and the outer tropics trail. The inner trail is home to the Tropical Flights aviary and the Monkey Village. The outer tropics trail passes by the Komodo dragons (Land of the Dragons), Asian elephants, jaguars, tortoises, iguanas, anteaters, Sumatran tigers (Isle of the Tiger), and an assortment of tropical birds. It also includes the Forest of Uco, a lush rainforest landscape. There is a one-mile walking trail that includes reproductions of a South American *mercado* and a scientific expedition and ruins, and at the Monkey Village, guests can get an intimate view of primate behavior. (Author's collection.)

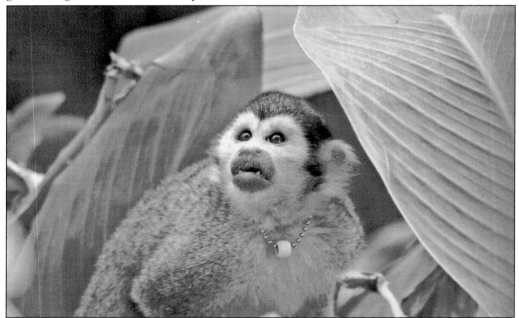

The Monkey Village, a 10,000-square-foot habitat just off the Tropics Trail at the Phoenix Zoo, allows visitors to get up close and personal, since the monkeys are not caged. It is the only walkthrough squirrel monkey exhibit in the United States. The little monkeys are all named after Star Trek characters (courtesy of a Trekkie volunteer). Visitors walk carefully through the entrance/exit so no monkeys escape, and they should always watch for monkey droppings. (Author's collection.)

The Children's Trail lets children get close to many small mammals from around the world. There is the Wallaby Walkabout along the trail. (Author's collection.)

Continuing on the trail will take visitors through Harmony Farm, featuring many farm animals, a petting zoo, and demonstrations on farming and agriculture oriented toward children. The farm includes a windmill and snack bar. (Author's collection.)

This cow is designed to teach how to milk. And the kids love climbing all over the tractors. The ground is covered with a rubberized material in case of falls. (Both, author's collection.)

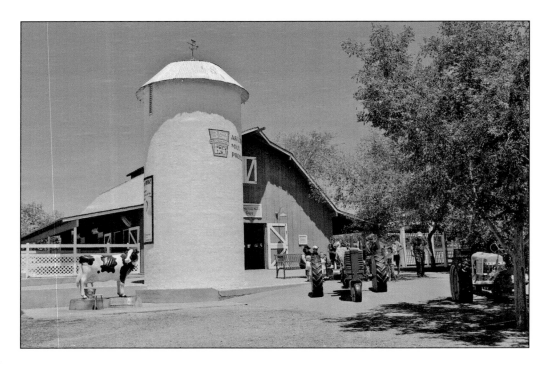

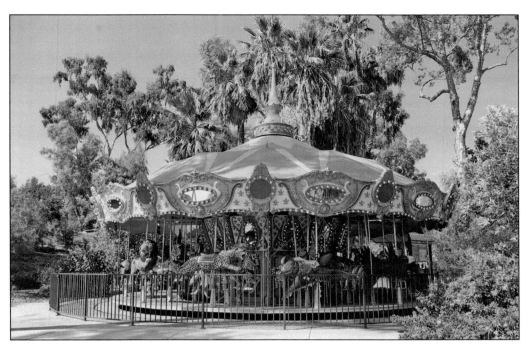

In addition to the trails, the zoo has several specialty attractions. Stingray Bay was opened in November 2006 and includes more than 30 rays and stingrays in a 15,000-gallon touch tank. The touch tank lets visitors touch the rays, whose barbs have been trimmed for safety. Bamboo sharks were added to the exhibit. An endangered species carousel is featured by the Leapin' Lagoon Splash Pad. The Safari Train provides a nonstop guided tour of the zoo. There are also the camel rides and the giraffe encounter. (Above, author's collection.)

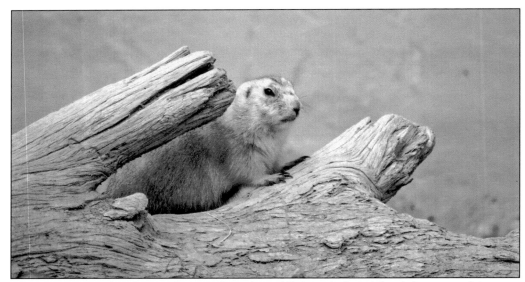

The Arizona Trail is designed to emulate the wildlife and plant life of the state of Arizona and the desert. This prairie dog is an example of one of the desert dwellers visitors can see. (Author's collection.)

The Hunt Bass Hatchery Caretaker's House was built in 1936 and renovated in the late 1990s. It is now known as Ruby's House in memory of Ruby, the famous painting elephant. Ruby's House has become a popular venue for weddings and other special events. The hatchery property was listed in the National Register of Historic Places on January 23, 2003, under reference no. 02001723.

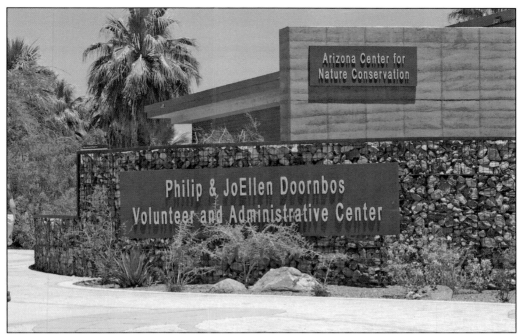

The Volunteer and Administrative Center opened in April 2015. It was designed by WDM Architects. It is three separate buildings sitting on a raised deck. The volunteer portion gives zoo volunteers a place from which to coordinate. In 2014, zoo volunteers contributed an estimated 65,000 hours. (Author's collection.)

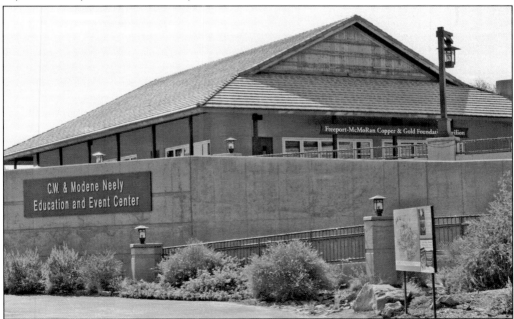

The Neely Event Center is a two-building complex designed to seat up to 300 with an open view of the private tiger yard. The complex has a flexible design to cater to both large and smaller groups. It is a venue that can be rented. It was designed by WDM Architects. (Author's collection.)

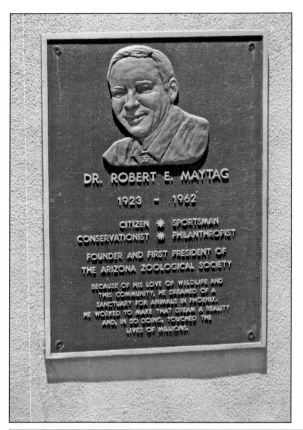

Near the exit is the Maytag Legacy Garden. The plaque memorializes Robert Maytag, allowing new generations of zoo visitors to wonder who he was and what made him so special. The donors listed in this area are part of the Antler membership. These are the donors who have named the zoo in their estate plans. The antlers animals leave behind are for the nourishment of other animals. The Antler membership is symbolic of this, leaving something behind to nourish the zoo. (Both, author's collection.)

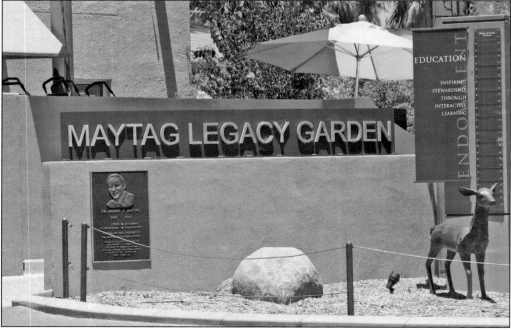

Five

No More Gum Machines Full of Treats

In the late 17th and early 18th centuries, zoological parks were private and owned by the elite. Their animals were considered interesting scientific collections. But during the late 19th century, a transformation took place that shaped the zoos of today.

Carl Hagenbeck opened the Tierpark Hagenbeck in Hamburg, Germany, in 1874. What made Hagenbeck's zoo different was the innovative way he displayed the animals. He designed their enclosures with the focus on displaying the animals as they would be in their native wild.

To achieve this wild look, Hagenbeck removed the bars and tore down fences between animals and the human visitors who came to see them. He implemented a series of moats and pits to separate animals from humans. Views of the animals were no longer blocked, and the visitors could almost feel as if they were right there in the rainforest or jungle.

This is seen in today's zoos. When the Phoenix Zoo first opened, many of the animals were in cages until larger, more natural habitats could be built. The zoo then kept animals in more closely contained habitats with a night house and an exhibit area.

"We want citizens to look upon the zoo as theirs. It really is theirs," said zoo director Jack Tinker. "Our goal is to continue to grow. We want to 'moat' all our exhibits, to take all animals from behind bars or wires. Everybody helped dig the lion moat in 1964."

Now visitors can view animals in moat-divided habitats, with each side watching the other. Presenting animals within their natural habitat not only makes it more entertaining to view the animal, but the animals can now also be somewhat ambassador for their species, teaching humans. "Zoo animals are ambassadors for their cousins in the wild," as Jack Hanna said.

In the early days of the Phoenix Zoo, gum machines were available to purchase treats to feed the elephant and giraffe. But zoos have evolved from being simply places for entertainment to organizations concerned with conservation. In the 1960s, the Phoenix Zoo's chimpanzees starred in an on-site animal show, often dressed in human clothes for guests' entertainment or posed with visitors for photo ops. Below, Chuck the chimp is in deep conversation with then governor Jack Williams. The topic of their conversation is the Aid-to-Zoo Horse Show. Chuck is wearing an A-to-Z button on the lapel of his sport coat.

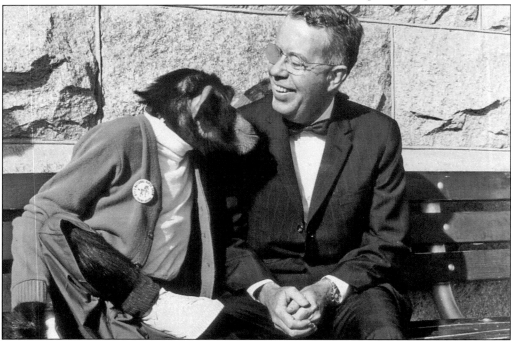

Paul Fritz, a well-known animal trainer of the 1960s, was hired by the zoo to train and direct Arizona's first trained-animal show. The show opened in April 1968. Fritz, 41, would also oversee the construction of a new $10,000 show arena in the Children's Zoo. The arena had a show ring, snack area, ticket booth, and public stadium seating to accommodate 750. Architect Nick Devenney of Devenney-Stahn drew up the plans.

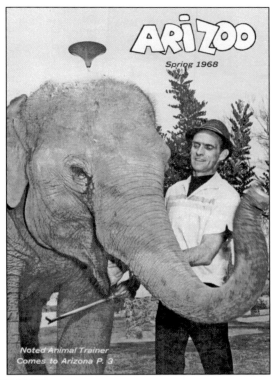

ARIZOO
Spring 1968

Noted Animal Trainer
Comes to Arizona P. 3

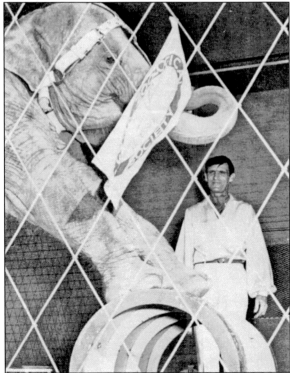

Saluting the Arizona Zoological Society with a flag, Heffalump rolls out on a barrel. The 45-minute show featured elephant acts and later big cats. There were also four chimpanzees owned by Fritz. These chimps were from his famous Del Monte Chimps. The animals put on shows and did tricks, much to the entertainment of their audience, but it was behavior they were taught and not something they would normally do in the wild. They were entertainment rather than a piece of living art to watch, learn from, and enjoy.

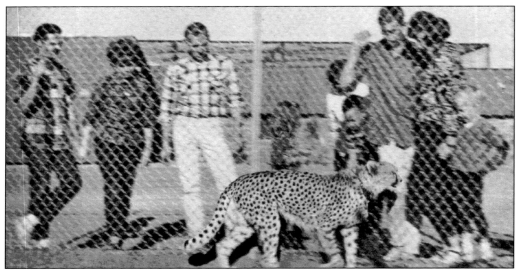

In the zoo's early days, it was not unusual to get up close to an elephant or giraffe or even a cheetah. Cassie, the Asian cheetah, prowls her new home. Notice how close zoo guests could get to some of the wild animals. Who is watching whom on each side of the fence?

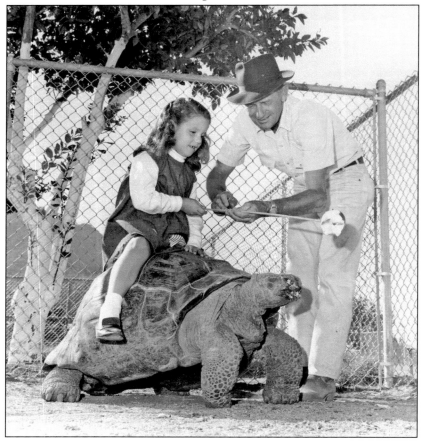

C.H. "Speedy" Barker (curator of animals) and a young guest coax a huge tortoise along in a version of the stick and the carrot. She rides tortoise-back using the apple on the string as an incentive for the tortoise to move. This was something done during the early days of the zoo. Then there was a change to allowing the animals to be viewed as they would be in the wild.

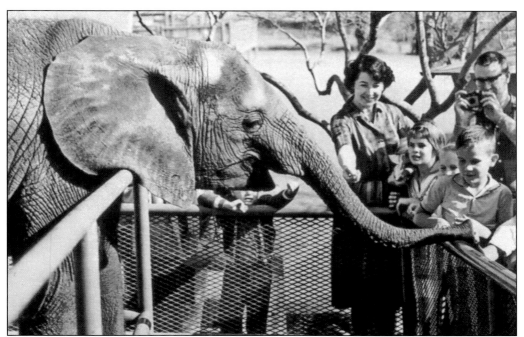

This shift to a more conservation-centered aims found that not only did visitors experience a stronger connection to nature as a result of their visit but also that zoos and aquariums can play an important role in conservation education and animal care. It did not lessen visitors' enjoyment of the zoo.

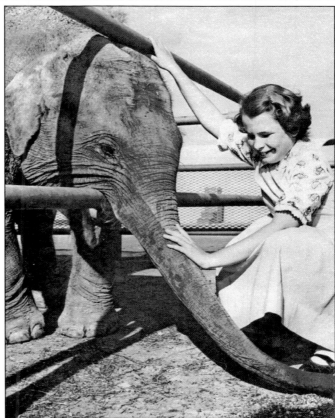

Of course, there is an exception to the letting animals be animals. Heffy and a young zoo visitor became friends. Pam Schmidt was allowed inside the people railing because she "sees" with her fingertips. She stated that Heffy's trunk felt like a vacuum cleaner. Today, the zoo has programs for the various populations it serves.

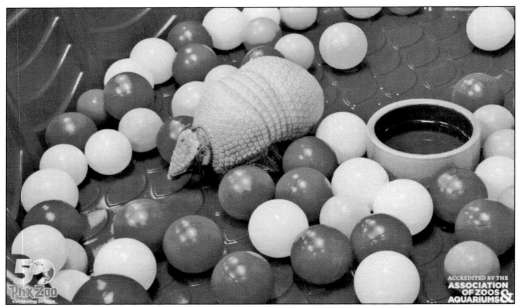

These photo ops and animal shows are gone. Now, keepers engage the animals by providing enriching activities, stashing food in toys, in trees, or in ice blocks. Their goal is to simulate behaviors that closely mimic life in the wild. Buttercup the armadillo plows her way through these balls. Perhaps they remind her of other armadillos all rolled up.

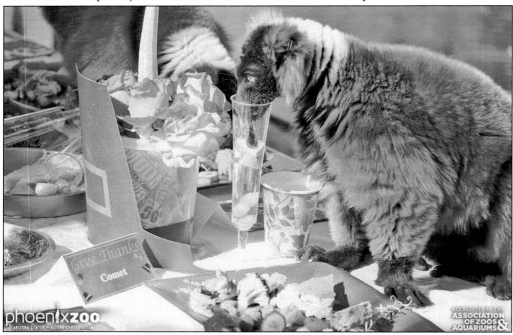

This activity is as much fun for the animal as it is for zoo guests. For the Thanksgiving holiday, a fine table is set complete with place settings and name tags. All the food is on the animal's diet, and the only spirit in that glass is the spirit with which the animal is drinking it. He might be the original party animal.

Six

ZOO CELEBRITIES

The Phoenix Zoo is a happening place. It offers events and venues for parties and weddings. But the animals are not the only stars of the Phoenix Zoo. Two-legged celebrities have also graced the zoo. Some of the local stars were even part of the early framework of the zoo.

One actress got the zoo an elephant and John Wayne. She also helped create a signature fundraising event. This was former Broadway actress Ann Lee Harris. She was the first president of the Phoenix Zoo Auxiliary.

Another celebrity got a gorilla for the zoo and had him flown in courtesy of *Playboy* magazine. Even Hugh Hefner played a role in aiding the Phoenix Zoo.

Early Phoenix Zoo Auxiliary member and actress Amanda Blake played a character named Kitty on the television Western *Gunsmoke*, and she also devoted her life to big cats. When *Gunsmoke* ended in 1975, Blake decided to spend more time promoting animal welfare, especially for cheetahs, which had previously proven to be nearly impossible to breed in captivity. But this two-legged celebrity was not through there. She cracked the breeding code of the cheetah and donated four of her own captive-bred cats.

The author of the book *Born Free*, Joy Adamson, stopped by the zoo while on a lecture and film tour to visit and make friends with a lioness cub not unlike her Elsa.

Former Broadway actress Ann Lee Harris was the first president of the Phoenix Zoo Auxiliary. She helped lead the initial fundraising for the Phoenix Zoo and helped make possible many of the early zoo exhibits and programs, including the world premiere of the Howard Hawks movie *Hatari!*

Amanda Blake (Miss Kitty from the TV show *Gunsmoke*) is holding two bobcats, but her forte was cheetahs. In the 1970s, she became the second person in the world to crack the code on how to breed cheetahs. She even lent some of the offspring she bred to zoological societies for research. Until her death in 1989, the actress bred seven generations of cheetahs at her home in Arizona, an incredible accomplishment for the threatened species. She and her husband, Frank Gilbert, donated four of their cheetahs to the zoo.

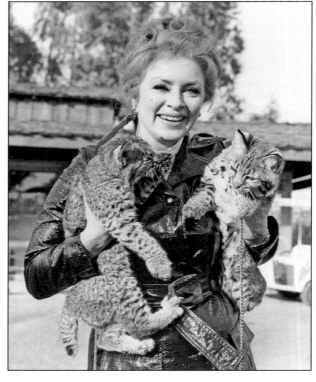

The author of the book *Born Free*, Joy Adamson spent time in the zoo's nursery making friends with a 10-month-old lioness cub. Adamson was in town on behalf of the World Wildlife Fund. She was on a lecture and film tour telling of her exciting adventures living in Africa for 25 years as the wife of the senior game warden of Kenya. A movie based on Adamson's book was released in 1966. The British film stars Virginia McKenna and Bill Travers as Joy and George Adamson. McKenna and Travers were greatly affected by the plight of wild animals after making the film. They worked to establish the Born Free Foundation, Ltd., founded on July 20, 1998. The Born Free Foundation works to prevent animal abuse and to keep wildlife in its natural habitat. Its logo is a lion, which is a likeness of Elsa.

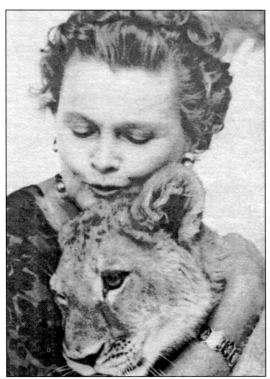

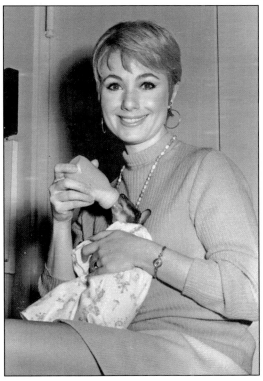

Actress Shirley Jones paid the zoo a visit while she was in town performing at the Phoenix Star Theatre (known today as Celebrity Theatre). While visiting the nursery, she was allowed to bottle-feed a baby wallaby.

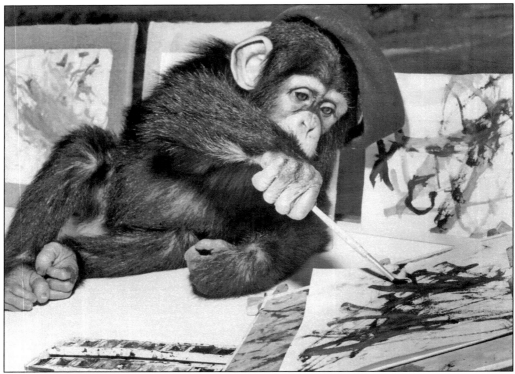

Chuck the chimp, a celebrity during the 1960s, was the first animal to paint at the zoo. He was known as the zoo's ambassador. Chuck would drive his pedal car around the Children's Zoo towing his friends.

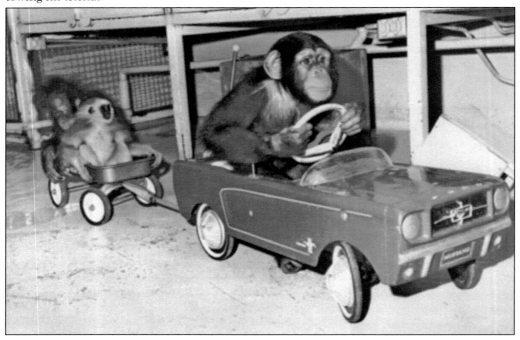

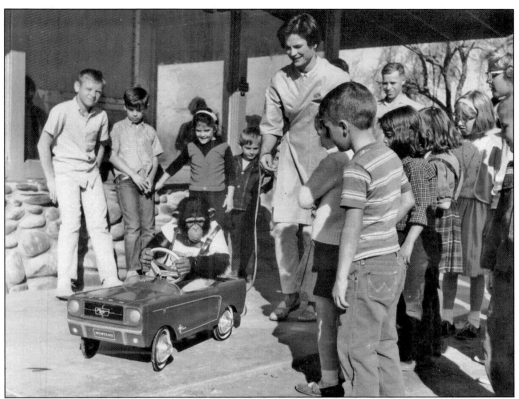

Chuck the chimp in his pedal car amused young zoo attendees. This was at a time in the 1960s when the public was up close and personal with some of the zoo animals. Chuck also liked to paint. Watercolor was his chosen medium. The public was so amazed by this that he had his own postcard.

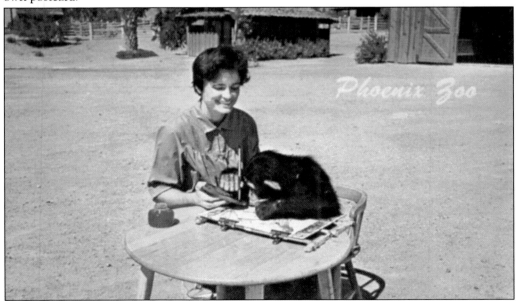

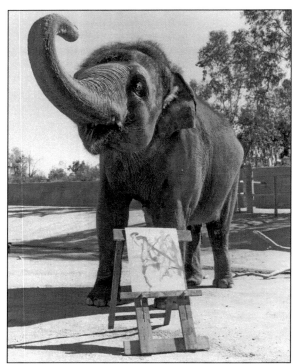

An Asian elephant named Ruby focused the world's spotlight on the Phoenix Zoo. Ruby arrived at the zoo in 1973 from Thailand. She caught her keepers' attention when they noticed her doodling in the sand with sticks, so they handed her a paintbrush and paint. A pachyderm Picasso was born.

Ruby quickly became known for her paintings. Art collectors all over the world were on an 18-month waiting list and paid hundreds of dollars for original Ruby prints. The sale of her prints raised over $200,000 for the zoo.

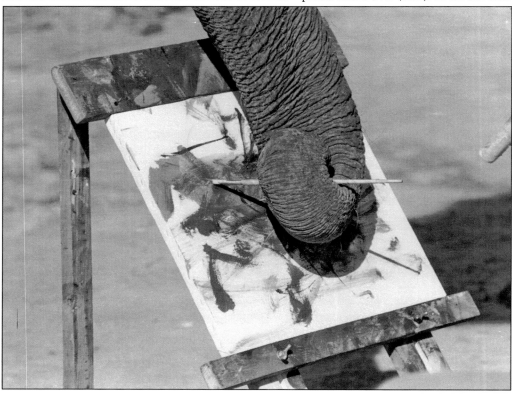

Ruby did more than 200 paintings, all abstract. In some, she used heavy brushstrokes and bright, bold colors. Others had a few delicate lines of color on an empty canvas. No two prints were identical.

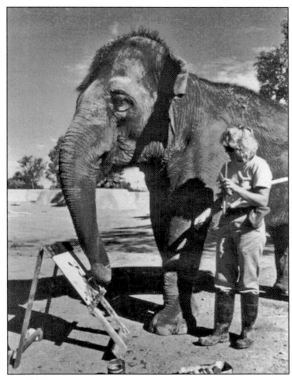

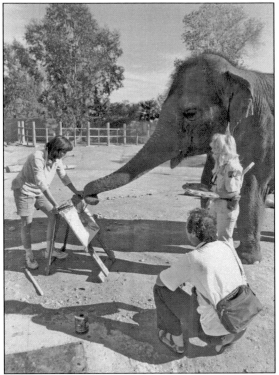

Ruby's painting process was simple. A handler brought out an easel, a blank stretched canvas, a box of watercolor brushes (human artist size), and jars of acrylic paints fixed onto a palette. Ruby next would tap one of the jars of paint and pick up a brush. The handler would take the brush, dip it into the selected jar, and return the brush to Ruby. This painting pachyderm sometimes would reuse a color or select another. After about 10 minutes, Ruby laid her brushes aside, backed away from the easel, and indicated that she has finished. When she was done with a piece, she was done, and nothing changed her mind.

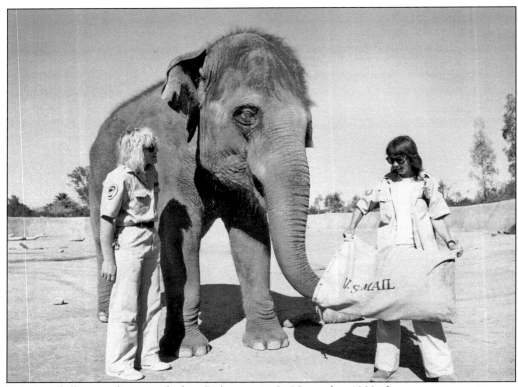

Painting skills were discovered when Ruby was 14. In November 1989, the zoo trainers set up an easel. *National Geographic* photographer Bill Thompson visited in December 1989. He prompted the zoo to sell Ruby's prints and use the money to benefit elephants whose survival in the wild was questionable. She was so popular that she received her own fan mail. Sadly, Ruby had to be euthanized in 1998 following severe birthing complications.

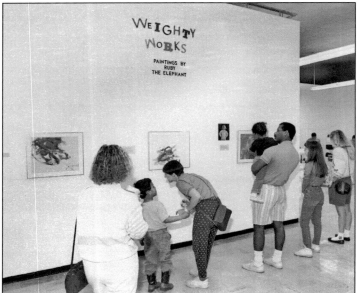

The zoo had just established the Phoenix Zoo Conservation Fund. Sales from Ruby's pictures would be placed there. The Bishop Gallery in Scottsdale offered to host Ruby's world premier art show and turn all the proceeds over to the zoo. The show opened in April 1990 with 39 paintings, and all sold in three days. A show of her paintings at the Arizona State University Art Museum in 1991 broke attendance records; the show was extended four weeks to meet the demand.

Seven

HAZEL AND JACK'S LOVE STORY

This is a love story that reads like a romance novel: two star-crossed lovers the public would not leave alone, denied love and heirs. They say three is a lucky number, and that would eventually prove the case for Hazel, the heroine of the story. Baltimore Jack would be the newcomer in town to woo Hazel. All of this sounds familiar—except the romantic couple is a pair of gorillas. Hazel was one of the original animals when the zoo opened in 1962. Her mate, Mongo, died in 1969, but late in 1970, zoo officials found a suitable mate, Jack, in Baltimore. A long-distance romance would not do, but how to get a six-foot-three, 300-pound, 18-year-old gorilla to Phoenix was the question. The zoo called in the Air Force, which was all set to help with the romantic rendezvous, but Washington halted the flight before it even left the ground. Commercial airlines did not want to remove seats, and Jack's ticket was outrageously priced. Enter the *Big Bunny* jet and an "Ape Ambulance."

Hazel the gorilla was one of the original animals when the zoo opened in 1962. In July 1961, she arrived from Cameroon with a male, Mongo. Mongo unfortunately died in 1969 of valley fever, leaving Hazel widowed. Zoo officials searched for a new mate for the lonely ape. Late in 1970, a suitable mate named Jack was found residing at the Baltimore Zoo.

This is baby Mongo with zoo dietician Edith Blake in 1961. They had just arrived in Phoenix, and society treasurer Theodore Rehm meets them on board the plane.

Baltimore Jack was purchased from the Baltimore Zoo, and the question was how to get the groom to Phoenix. The Air National Guard was contacted and agreed to fly Jack and his attendants to Phoenix on a scheduled flight. Then the Defense Department in Washington nixed the idea. It declared that regulations prohibited civilians on Air Force planes. Since Jack was a gorilla, he could fly, but his veterinary attendant could not. The zoo then consulted a commercial carrier. It needed one that was the right size, had a pressurized cabin, and would take no more than nine hours. TWA, United, and American turned the zoo down, mostly because seats would have to be removed to accommodate the huge ape. When the zoo did locate a carrier that would fly Jack, it was for $10,000, twice the price of the gorilla.

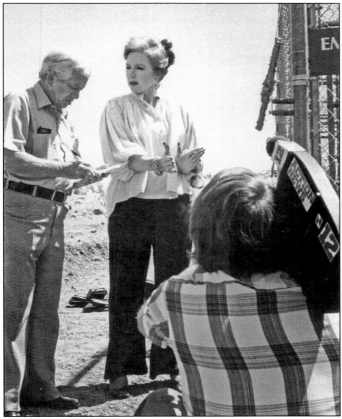

In desperation, the zoo reached out to Amanda Blake, who was a member of the auxiliary and had Hollywood connections. Blake starred as Miss Kitty on television's Western hit *Gunsmoke*. CBS produced the show, which Blake was on for 19 years, so she reached out to the network. CBS offered a Learjet for $3,000.

Hugh Hefner, publisher of *Playboy* magazine, heard about the plight the zoo was facing. To make this love match, he offered his plush DC-9 jet, called *Big Bunny*. Accompanying Jack from Baltimore were Baltimore Zoo director Art Watson, assistant director John Moore, Ray Thompson (president of the Baltimore Zoological Society), Dr. Mitchell Bush (a Johns Hopkins University veterinarian), and his assistant, Lanamay Heeley. Jack was sedated and strapped to the big round bed at the back of the black jet. The doctor carried a .45 pistol just in case. News of Jack flying in the *Big Bunny* prompted Dr. Jack Hyles, a traveling evangelist conducting a revival in Phoenix, to question the Christian morals of Hazel's new beau traveling with such company. Zoo officials assured the public and the pastor not to worry. Jack would be strapped down and sedated for the entire trip and would not even see any bunnies or bunny-style stewardesses.

Taxiing to 100 feet from the "Ape Ambulance," the *Big Bunny* is about to deliver the heavily sedated Baltimore Jack. The "Zebra Ladies," who dressed uniformly on state occasions, are led by Amanda Blake.

Jack was greeted by about 150 well-wishers, a delegation from the Phoenix Zoo Auxiliary, and a battery of photographers, reporters (both local and international) and TV cameramen on the tarmac of Sky Harbor Airport. Everyone was hoping to catch a glimpse of Jack. All that was missing was a high school marching band. All anybody saw or photographed of Jack was his posterior, which was not his best side.

Here, Jack is still heavily sedated and surrounded by staff anxious to get him aboard his Ape Ambulance and to the zoo, where his new home and future mate waited for him. All the public was able to see was Jack's back end.

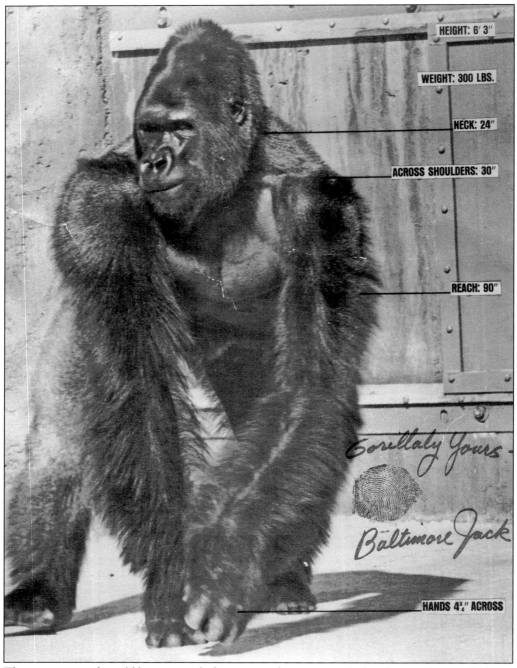

HEIGHT: 6' 3"

WEIGHT: 300 LBS.

NECK: 24"

ACROSS SHOULDERS: 30"

REACH: 90"

Gorillaly Yours –

Baltimore Jack

HANDS 4¾" ACROSS

The airport crowd would have to settle for a trip to the zoo to see Jack in his gorilla moat habitat. It was free of bars and, unlike the excitement at the airport, offered unblocked views of him. So, like any celebrity, Jack had autographed pictures of himself ready to hand out to his fans.

The wedding was one of the biggest things to happen in Phoenix at the time. A Phoenix jeweler offered 18-carat gold rings in miniature bananas, and a local dentist offered to provide the wedding cake. Jack and Hazel were "married" in July 1970. While "romance" between Jack and Hazel made international headlines and expectations were high for offspring, it did not happen. Hazel showed no interest in Jack, so no pregnancy occurred. Then Baltimore Jack became ill. Pneumonia was suspected. He died on September 6, 1972. An extensive autopsy proved it was valley fever and turned up another interesting tidbit: Jack was sterile. His remains were donated to the anthropology department at Arizona State University for research. Encased in a fiberglass tank and floating in a strong preservative solution, the late Baltimore Jack became the first occupant of the arts building after it was remodeled.

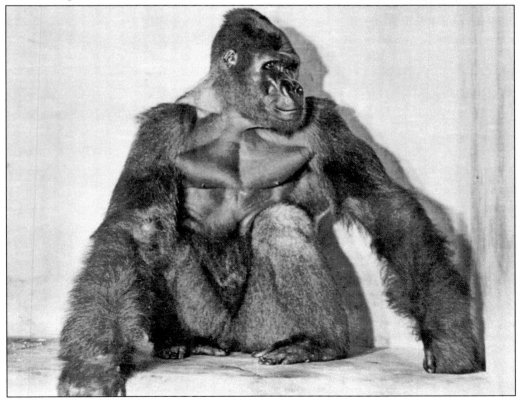

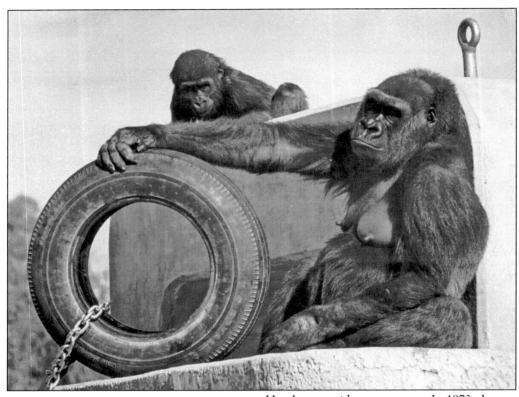

Hazel was a widow once more. In 1973, she was sent to San Diego Wild Animal Park to mate with a gorilla named Trib. Trib was a tall, $10,000, 400-pound fellow named after the local newspaper that donated him. The third time was the charm, and in January 1975, Hazel gave birth to a male named Fabayo (also known as Rocky).

Hazel died in 1991. A tribute sculpture of Hazel the gorilla sits near the gift shop. The sculptor of this bronze is Vince Maggiore along with his assistant Justo Ruiz-Torres. Shidoni Foundry cast the bronze. *Hazel* was unveiled in November 1993. (Author's collection.)

Eight

EXTINCT NO MORE

In the early 20th century, William Temple Hornaday led the charge to preserve a vanishing icon of the American West: the bison. A captured bison calf became the inspiration for the creation of the National Zoo, an institution meant to preserve and conserve native wildlife.

Hornaday was quite the unique character in the chronicles of conservation. He included taxidermy, zoology, and conservation among his many interests. He also founded the American Bison Society in 1905. The society's goal was not just to preserve the disappearing American bison by placing them in zoos but also to reintroduce the animal back into the wild. It sought to establish conservation herds and worked with the Bronx Zoo to create a captive breeding program. The bison breeding program at the Bronx Zoo is considered one of the earliest successful zoo engagements in conservation and reintroduction of a vanishing species.

Most zoos have evolved from being just places of entertainment to organizations concerned with conservation. The Phoenix Zoo is one of these institutions. In the early days, it was common for animals to be dressed in clothes. The shift to more conservation-centered aims found that visitors not only experienced a stronger connection to nature as a result of their visit but also believed zoos and aquariums play an important role in conservation education and animal care.

The Phoenix Zoo was and is dedicated to such efforts. Its participation in large-scale conservation initiatives reaches back to 1962, when "Operation Oryx" began. The zoo participates in the American Zoological Association (AZA)'s Saving Animals From Extinction (SAFE) program. SAFE is a commitment by all 230 AZA-accredited zoos and aquariums to harness their collective resources, focus on specific endangered species, and save them from extinction by restoring healthy populations in the wild.

The Phoenix Zoo continues to grow, adding new exhibits, educational programs, and conservation programs. In 2007, it opened the Arthur L. and Elaine V. Johnson Foundation Conservation Center in an effort to centralize and make conservation efforts more efficient. Currently, the zoo is engaged in the conservation of eight species native to Arizona: black-footed ferrets, Mount Graham red squirrels, Chiricahua leopard frogs, narrow-headed garter snakes, desert pupfish, Gila topminnows, California floaters, and spring snails. All are housed on the zoo's grounds.

During the summer of 2014, the zoo launched a rebranding program. The goal for the rebranding was to begin moving the public perception of the zoo from simply a fun place to visit to a much more significant image of conservation. The logo chosen started off showcasing the oryx but was designed to showcase other animals. The zoo remained the Phoenix Zoo with a new logo, but the Arizona Zoological Society would now be known as the Arizona Center for Nature Conservation.

Beginning in 1962 with Operation Oryx, one of the world's most successful global wildlife conservation programs, the zoo has become world-renowned for its contributions to the field of conservation science.

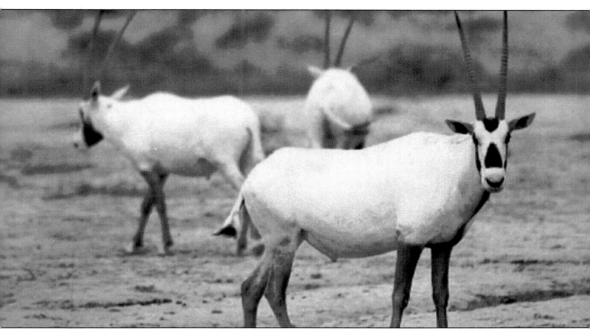

Arabian oryxes were among the world's rarest animals, and they were in trouble. They were first hunted on foot or horseback with crude weapons, but that changed to high-powered vehicles and even airplanes. Crude spears were replaced by rifles and even machine guns. As a result, there was hardly an oryx left alive in its native desert. In 1963, the Phoenix Zoo established the "World Herd" of Arabian oryxes just a year after opening. To conservationists, the Phoenix Zoo's herd of Arabian oryxes represented a successful breeding program that released more than 100 back into the Middle East.

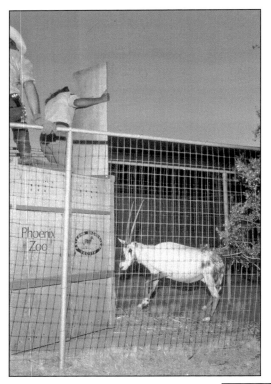

The herd had grown healthily and steadily, so much so that the zoo notified Operation Oryx that it was running out of space and needed to transfer surplus animals to other zoological institutions. There was also another reason to separate the herd. The animals that comprised the population of the Phoenix Zoo were the last of the species, and if something devastating such as disease were to hit the herd, all the work saving them could be wiped out. Today, more than 7,000 Arabian oryxes exist worldwide, bringing the species back from the brink of extinction.

It is estimated that about 100,000 cheetahs resided in Africa and Asia near the beginning of the 20th century. This number plunged to 15,000 animals by 1975. At the start of 2015, the cheetah population was 10,000, and it continues to drop at an alarming rate. A study published in the December 2016 *Proceedings of the National Academy of Sciences* determined that only 7,100 adult cheetahs are left in the wild. Cheetahs, the fastest land animals on the planet, are facing a staggering drop in numbers in large part due to habitat loss, conflict with farmers and ranchers, and illegal hunting. Urgent protection measures are needed to prevent extinction of this beautiful species of cat. Fortunately, institutions like the Phoenix Zoo have been ahead of the curve investing in cheetah conservation.

On June 3, 1987, the Mount Graham red squirrel was listed as endangered under the Endangered Species Act. The squirrel was actually thought to be extinct in the 1950s but was rediscovered two decades later. The squirrel's forest habitat has been impacted by wildfire and disease. This has reduced cover from predators and diminished available food resources; which has led to a reduction in their population. In addition, an introduced species (Abert's squirrel) is now outcompeting Mount Graham red squirrels for what limited food resources there are.

The Phoenix Zoo became involved with the black-footed ferret breeding and release program in 1991. It was the fourth breeding facility at that time. Presently, there are six black-footed ferret breeding facilities in the world, five of which are located in zoos. The sixth is the breeding center headquarters in Carr, Colorado. Through the reintroduction program, it is estimated that over 1,000 black-footed ferrets now exist in the wild.

Chiricahua leopard frogs bred at the Phoenix Zoo are released in forest streams to restore the species in Arizona. The frogs used to be abundant in Arizona until destruction of their habitats, among other factors, led to a decline in their numbers. They are listed as threatened on the endangered species list. The Phoenix Zoo collects egg masses and raises them in tanks at the zoo until they are advance-stage tadpoles. Doing so ensures that at least 90 percent of eggs develop and survive.

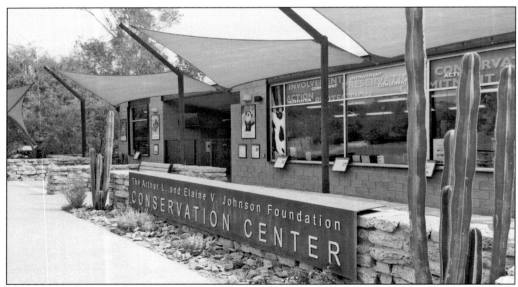

Money for the conservation programs comes from entrance fees. The black-footed ferret program costs the zoo about $150,000 a year, while breeding Chiricahua leopard frogs costs $65,000 a year, according to Stuart Wells, the zoo's former director for conservation and science. The Arthur L. and Elaine V. Johnson Foundation Conservation Center at the Phoenix Zoo currently maintains a population of Mount Graham red squirrels. Because the temperatures in Phoenix are much higher than on Mount Graham, they are housed in a temperature-regulated building. The building is maintained at 65 to 72 degrees Fahrenheit throughout the year. (Author's collection.)

Nine

PROGRAMS FOR ALL AND CHARITIES FOR OTHERS

As a nonprofit charitable organization, the Phoenix Zoo provides experiences that inspire people and motivate them to care for the natural world. To promote the zoo and its role in nature and Phoenix, a variety of special programs are run year-round. The zoo is always creating new experiences for all ages. There are after-hours wine-and-dines. Or the zoo might bring mountains of snow to the desert for the children to play in. Programs are designed with an eye to the zoo and conservation, such as Celebrate the SciTech Festival at the Phoenix Zoo with a Conservation Science Night. Another event is a celebration of getting healthy and staying fit with an animal twist: the First Annual Zoo Move & Groove Festival.

Visitors can experience the zoo in a unique way at Night Camp. They can see animals up-close, take a tour by flashlight, and wake up as the animals do. Twilight camps are available for those who would like to experience the zoo at night but would rather sleep in their own beds. Special tours and behind-the-scenes experiences are available as well. Horse Hands at the Phoenix Zoo is a unique program including equine caregiving and horseback riding lessons led by Certified Horsemanship Association (CHA)–accredited instructors. The zoo also provides venues for charity events, walkathons, camps, and company picnics.

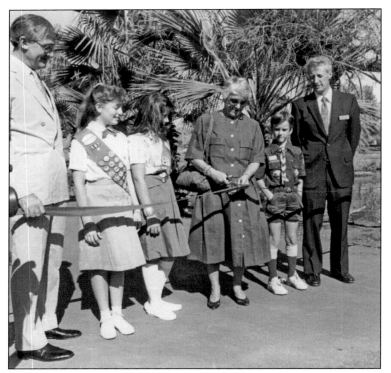

Girl and Boy Scouts have a good relationship with the zoo. They have sleepovers and other events to help earn merit badges. At a special Scouting event helping Scouts learn about conservation, they listen to zoo staff talking about the day's topic. Girl and Boy Scout troops may spend the night at the Phoenix Zoo. Each night is prepared for a specific Scout level and badge work. The Scout camps consist of guided trail hikes, animal discoveries, and educational activities.

Born from a spirit of community and the efforts of a small group of dedicated volunteers, the Phoenix Zoo has enjoyed a truly remarkable first 50-plus years. The zoo relies on over 300 active volunteers to support the staff's mission of "providing experiences that inspire people and motivate them to care for the natural world." Volunteers help in nearly a dozen departments and over 100 roles, from education and fundraising to horticulture and assisting keepers. Volunteers make an impact every day. (Author's collection.)

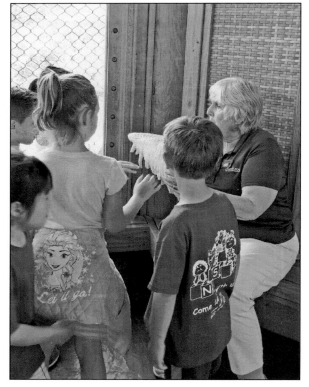

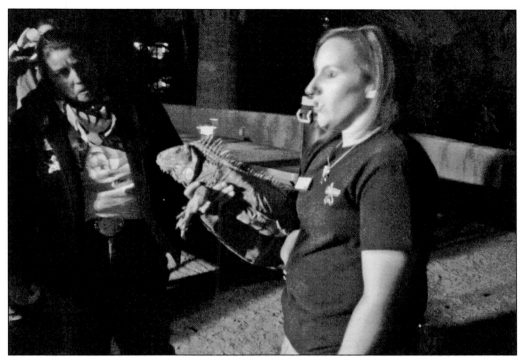

Night Camp lets guests experience the zoo in the dark, see animals close-up, take a tour by flashlight, and wake up with the animals. Tents are provided, and staff is on hand to guide the tours, show some of the animals, and answer questions. These camps can be just for families, specific groups, just children, or just grown-ups. Guest go behind the scenes and learn fascinating items about the zoo, like the old jeep that landed in one of the lakes. It sank, and the zoo chose to leave it. Rumor has it folks can still hear its radio playing. Pictured below enjoying a hedgehog in a classroom is an all-women club, Sisters on the Fly. Twilight camps are also available for those who would like to experience the zoo at night but would rather sleep in their own beds. (Both, author's collection.)

CAMP ZOO
Phoenix Zoo

In the beginning, Camp Zoo was known as the Summer Institute for Children. One day a week for six weeks, from 8:00 a.m. to noon, children ages eight to 15 were taught a combination of arts and crafts and nature studies.

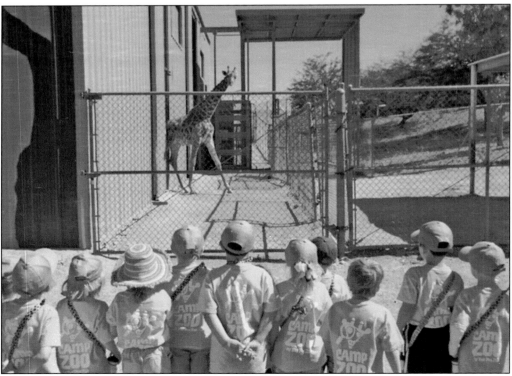

Two hours were devoted to arts and crafts and two hours to nature studies. There was a break in between for refreshments of fruit punch and cookies. The entire six-week program came with all the supplies and instruction at a cost of only $12 per child. In 1967, enrollment was 1,053 children.

Children can have fascinating adventures with the natural world at Camp Zoo. Each weeklong session is filled with up-close animal encounters, behind-the-scenes experiences, hands-on activities, games, in-depth investigations, and organized free time. All camp lessons and activities are age-appropriate and designed for multiple learning styles.

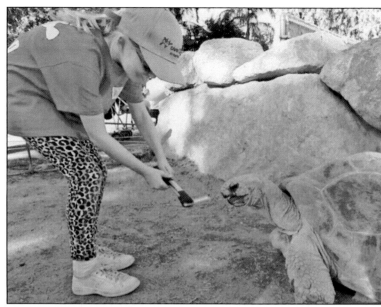

A primate handler demonstrates how the orangutans have been trained to respond to various signals. This training was done to make it easier to examine the animals come checkup time. Two different camp topics are offered on alternating weeks, so children can attend more than one session at Camp Zoo. (Author's collection.)

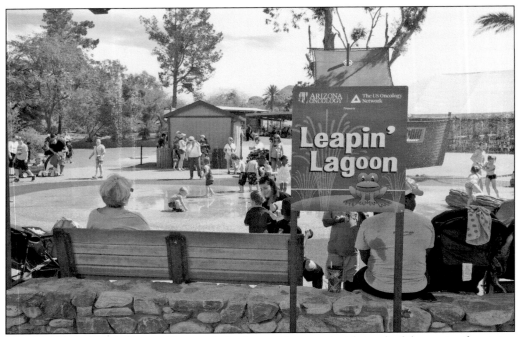

Phoenix is hot, and the Leapin' Lagoon helps keep visitors cool with its playful spouting fountains of water. A visit here is part of the regime for summer camp. (Author's collection.)

In February 2015, the zoo opened its 4-D theater, the first of its kind in Phoenix. Four-D audiences feel totally immersed in the movie while the special effects magic happens. Smells, water, wind, and other various theatrical effects, as well as specially synced seat movement, are utilized to make members of the audience feel like they are part of the film.

A Discovery Tour is a 90-minute guided tour through the zoo in an eco-shuttle cart. On this tour, passengers are able to hop on and off the cart for closer viewing and for photo opportunities. Discovery Tours only visit the normal public areas of exhibits, not behind-the-scenes areas. If guests are willing to pay a little more, there is a 60-minute Backstage Adventure for an insider's glimpse at some animal habitats. (Author's collection.)

The Phoenix Zoo offers programming for all ages. Older zoo lovers can swing by for a happy hour with a wild side: Roars & Pours at the Phoenix Zoo. Guests 21 and older can sip and stroll select zoo trails while enjoying craft brews, wine, and food, plus animal encounters, yard games, and live music.

The Phoenix Zoo has become one of Phoenix's brightest holiday traditions with ZooLights presented by SRP, one of the city's power providers. Yearly, ZooLights shines with millions of lights, a three-story lighted tree, hundreds of glimmering light displays, lakeside Music-in-Motion shows, and more. "The magic of ZooLights, with its millions of lights and its hundreds of twinkling displays, has provided priceless memories and become a Valley tradition for countless guests over the past two-and-a-half decades," says Bert Castro, president and chief executive officer of the Arizona Center for Nature Conservation and Phoenix Zoo, in a Zoo/Zoolights press release dated November 16, 2016.

Dinosaurs in the Desert is a seven-month-long exhibit. The 23 prehistoric creatures live on the Zoo's Desert Lives Trail. The dinosaurs move and make sounds as guests walk on self-guided tours. Special programming is planned around the exhibit. (Author's collection.)

Nature Connects®: Art with LEGO® Bricks by Sean Kenney, a collection of 27 sculptures crafted from one million LEGOs, was one of the special visiting exhibits at the zoo. This stunning peacock is his second-largest piece. At nearly seven feet wide and five feet tall, the peacock is made up of 68,827 pieces. Kenney said of his creation "It is the most visually intricate and time-consuming sculpture he has ever designed." The LEGO Group began manufacturing the interlocking toy bricks in 1949. *Lego* is derived from the Danish phrase *leg godt*, which means "play well."

The Phoenix Zoo offers more than 15 unique and beautiful venues for weddings, corporate events, proms, retreats, and any number of special event needs. All evening rentals include a basic lighting package. When needed, evening rentals also include umbrella heaters and guest transportation to and from the zoo entrance and the venue. Large corporations hold their public events, team building activities, and memorials at the zoo. Shown here is the Mayo Clinic's Transplant Patients Caregivers picnic. It was a way for patients to acknowledge the people in their lives who helped during their organ transplants. The zoo is also very popular for walkathons. (Both, author's collection.)

Ten

ZOO TRIVIA

Trivia is described as little bits of information that usually have little value. That aside, trivial bits of information can sometimes be more educational; they just don't seem to fall in a particular chapter. While bits might be trivial, they are often fun and leave one saying "I didn't know that."

Some bits of trivia include alligators may go through more than 3,000 teeth in their lifetime; or a zoo can be a post office for a day; or no two zebras' stripes are alike; or a white rhino is really gray.

Ever wonder how big a giraffe's heart is or how an animal's horns can act like a radiator? What about the sharp hooks on a lion's tongue? Zoo trivia is fun facts that may have a zoo guest looking differently at a lion as it grooms itself. And speaking of lions, any idea how much the zoo's male lion eats? No? Then keep reading.

Back in the early 1970s, the alligator exhibit was in an area that had a little bridge, and the alligators would sun themselves in the dirt beside a very small fence that could be easily climbed. And daredevils use to do just that.

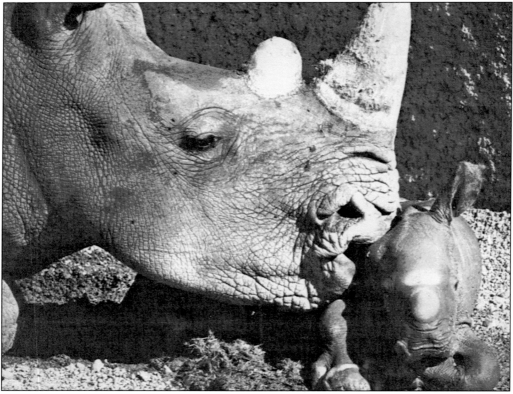

How can an animal be white when it's gray? A popular theory says that Dutch settlers in South Africa noticed some rhinos that roamed their farms were different from the others. The Afrikaaners named this species of beast *weit* (wide) rhino. The English-speaking settlers who came later used the Dutch word but mispronounced it as "white"—and it has been that ever since. White rhinoceros are the second-largest land mammal in the world and may grow to three or four tons; only the elephant is larger. Rhinos are one of the most endangered species. LouLou the rhino's stay in Phoenix helps raise awareness of current conservation efforts. Pictured are Tambile and her calf Howell B., named in memory of Dr. Howell B. Hood, the Phoenix Zoo veterinarian from 1965 to 1989. (Author's collection.)

Elephants feed on 200 pounds of alfalfa and Bermuda hay, grain, hay pellets, and various vegetables per elephant per day. The carnivores at the zoo eat more than 700 pounds of raw meat each week, or 36,400 pounds per year. The male lion alone eats 5,000 pounds of food, 14 percent of the zoo's annual total. (Author's collection.)

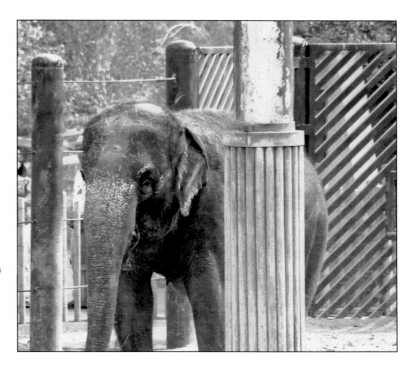

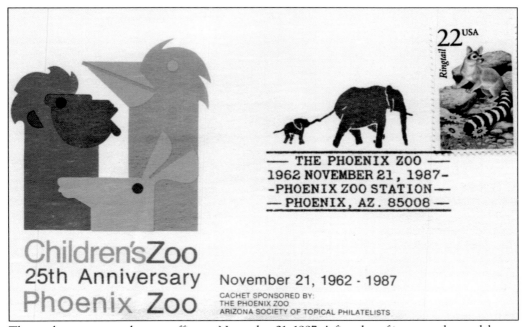

The zoo became a one-day post office on November 21, 1997. A first-day-of-issue envelope celebrates the Children's Zoo's 25th anniversary. The envelope was date-stamped at the zoo, creating a nice collectible. (Author's collection.)

Bert Castro, the zoo's chief executive officer and president, wanted to thank the auxiliary for 50 years of service, so he commissioned a sculpture by a Phoenix artist, Gedion Nyanhongo. Nyanhongo said he wanted to find the right stone to make a zebra, so he went to his home country, Zimbabwe. With the help of fellow artists and relatives, he made a life-size zebra. Nyanhongo said the zebra is made of a gray slab of springstone. With waxing and polishing, it turns black. The sculpture was unveiled in 2011. (Author's collection.)

Grévy's zebras are the most endangered of the three zebra species. They are also the heaviest, weighing up to 1,000 pounds. Their stripes are the most delicate, with lines that continue all the way to their hooves. The stripes on a zebra are just as unique as human fingerprints.

Watusi cattle specifically tolerate temperature and weather extremes. The cattle have large horns that act as radiators; their blood circulates through the horns, where it is cooled, and returns to the body. (Author's collection.)

Giraffes have six-foot-long necks and legs; they are tall enough to peer into a second-story window. Females can weigh 1,500 pounds, while males can reach 3,000 pounds. The giraffe's heart is huge. It is two feet long and weighs about 25 pounds. (Author's collection.)

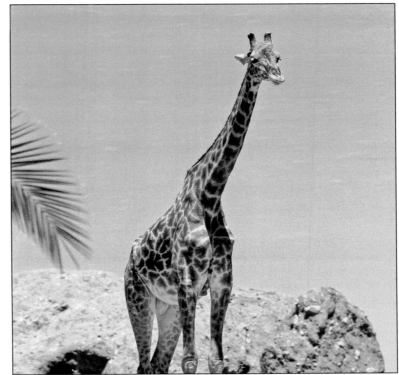

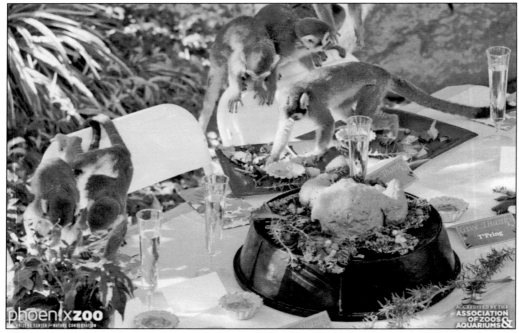

All the squirrel monkeys in the zoo are named after Star Trek characters. A Trekkie volunteer came up with the idea.

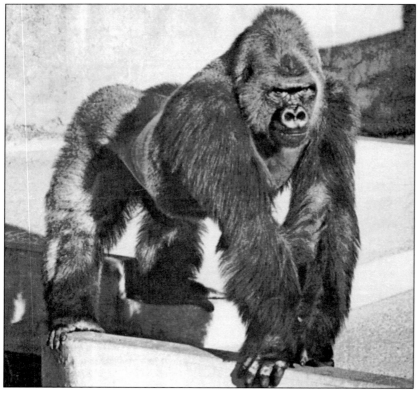

A gorilla oddity is the males' habit of hammering Tarzan-like on their broad chests with their open palms when excited or angry. This produces a muffled boom that resembles the sound made when a barrel is stuck with a padded club.

Lion's tongues have rows and rows of sharp hooks. These hooks are designed to get meat off bones quicker and help with grooming. All feline tongues, from those of tiny house cats to those of 600-pound Bengal tigers, are covered with tiny barbs or hooks, giving the tongues a rough texture. These microscopic projections face toward the cat's throat and act as a stiff brush that helps groom their coats. (Author's collection.)

The Phoenix Points of Pride are 33 landmarks and attractions within the Phoenix city limits that represent the best features of the city for both residents and visitors. Each Point of Pride was selected through an election process that involved 40,000 residents voting for their favorite destinations and resources. The Phoenix Zoo was declared a Phoenix Point of Pride in 1992. It was one of the first locations to receive the honor.

Discover Thousands of Local History Books
Featuring Millions of Vintage Images

Arcadia Publishing, the leading local history publisher in the United States, is committed to making history accessible and meaningful through publishing books that celebrate and preserve the heritage of America's people and places.

Find more books like this at
www.arcadiapublishing.com

Search for your hometown history, your old stomping grounds, and even your favorite sports team.